BRUTALKINSHIP

"I anguish over the suffering endured by hundreds of chimpanzees at the hands of humans.

They suffer in the wild as their habitats are destroyed and as mothers are shot and their infants are seized."

JANE GOODALL

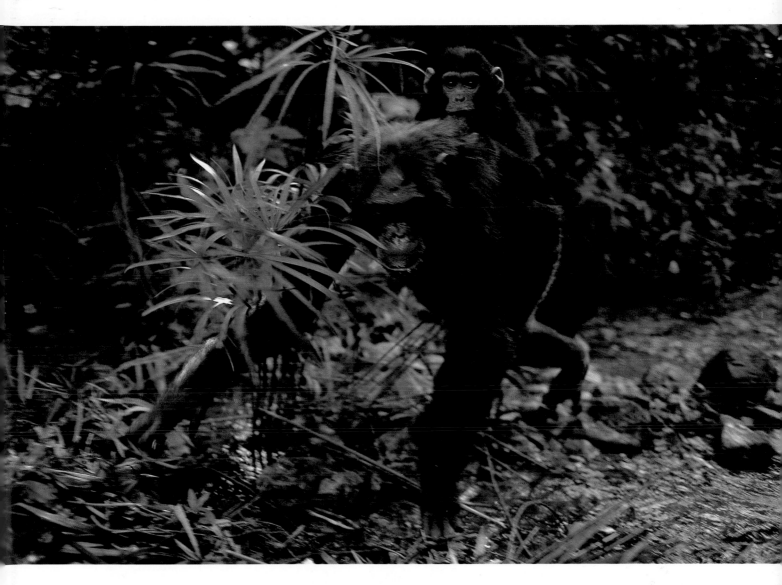

Above: Fifi, mother of six, carrying her son Ferdinand. Fifi, a competent and relaxed mother, is one of the highest-ranking females in the community. As a mother, Fifi is attentive and playful, being neither punitive nor permissive with her offspring. Bonds between Fifi and all the members of her family are strong and enduring. *Pages 4-5*: Fifi. *Pages 6–7*: Face to face with humanity's closest relative. Jane Goodall has spent thirty-eight years studying the ways of chimpanzees in the wild. Here she draws from that intimate understanding to comfort a chimp in captivity—La Vielle, an aged female half-crazed from spending years alone in a Congolese zoo. In 1994, the Jane Goodall Institute moved La Vielle to a happier home— a sanctuary nearby. *Pages 8–9*: Whiskey, a five-year-old chimpanzee, is held captive in a car-repair garage in Burundi. He is chained by his neck in a dark, wet, disused lavatory, having become too strong to continue as a family member.

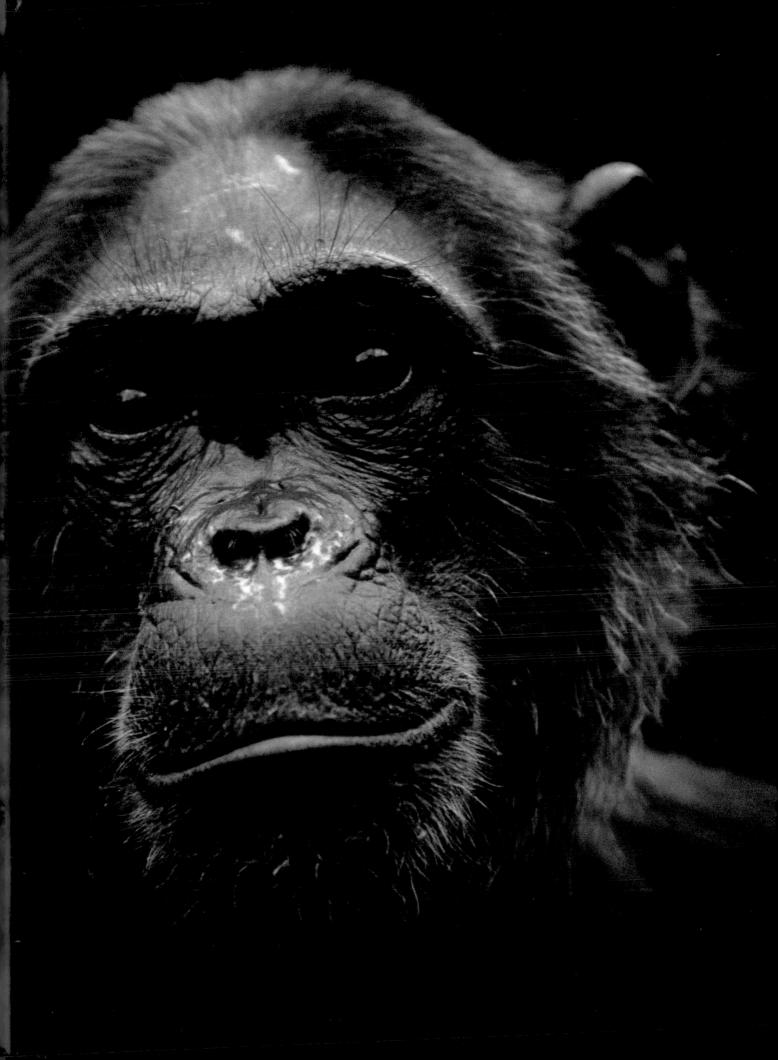

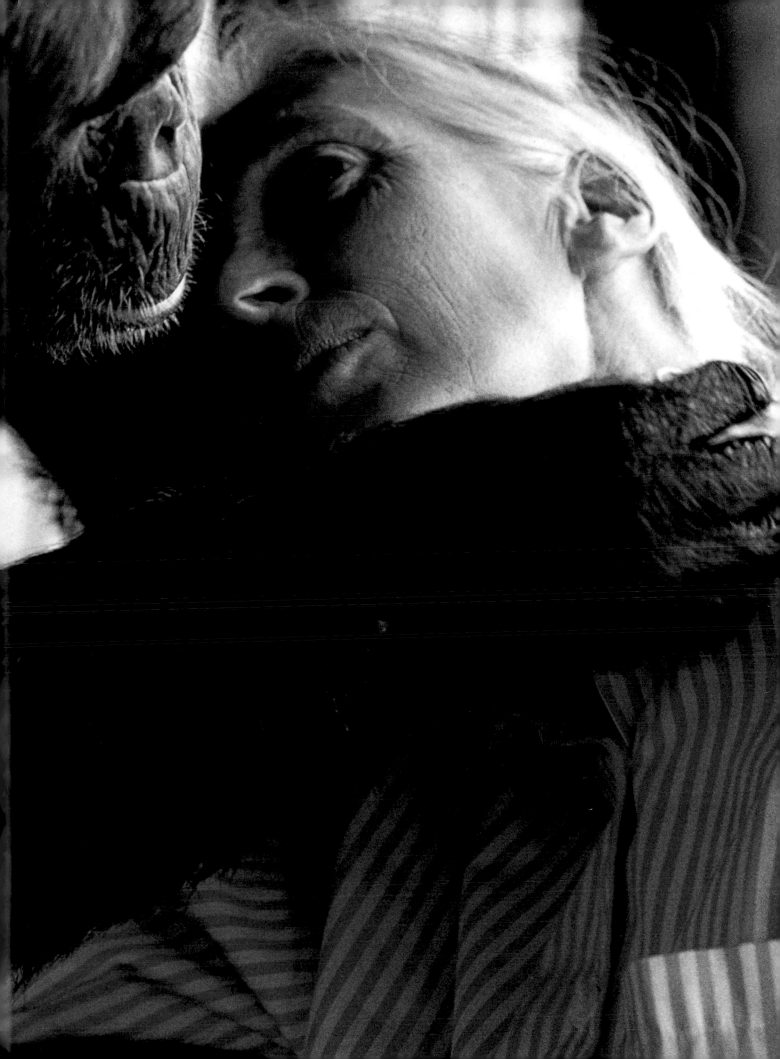

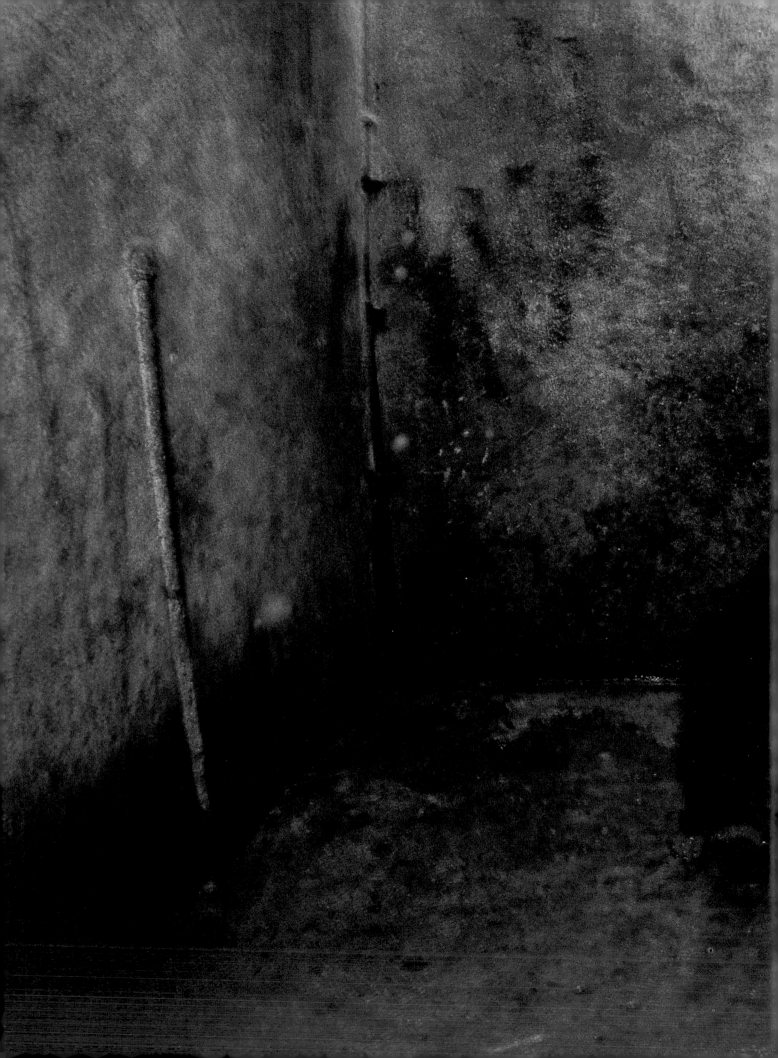

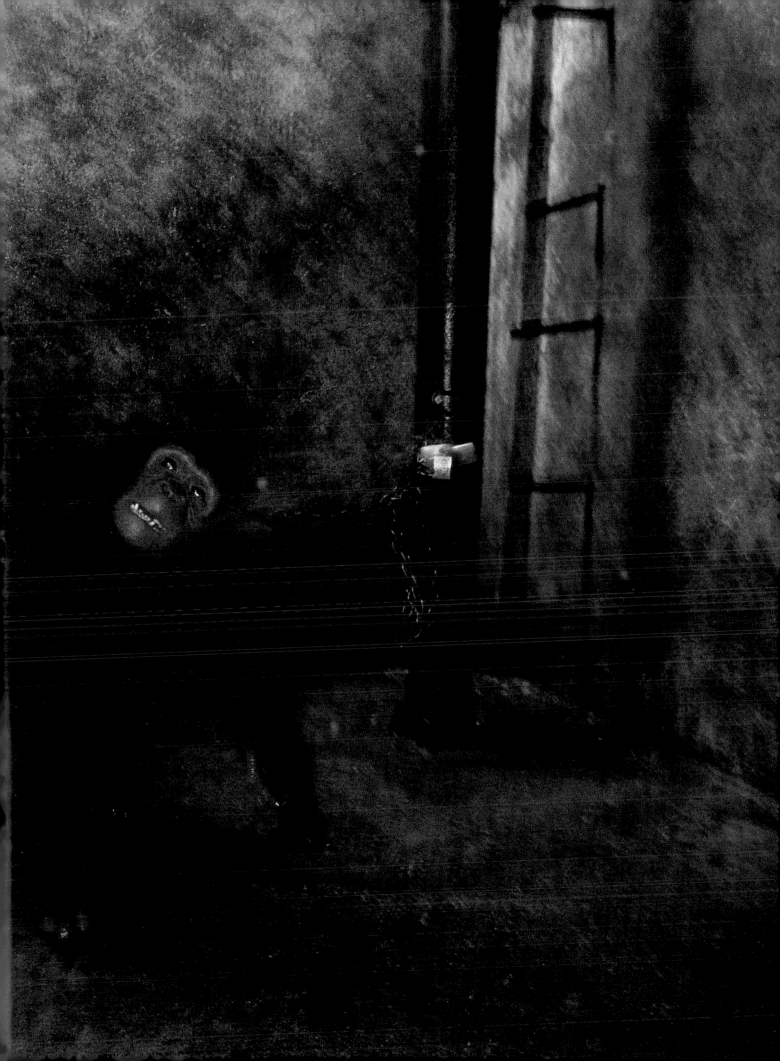

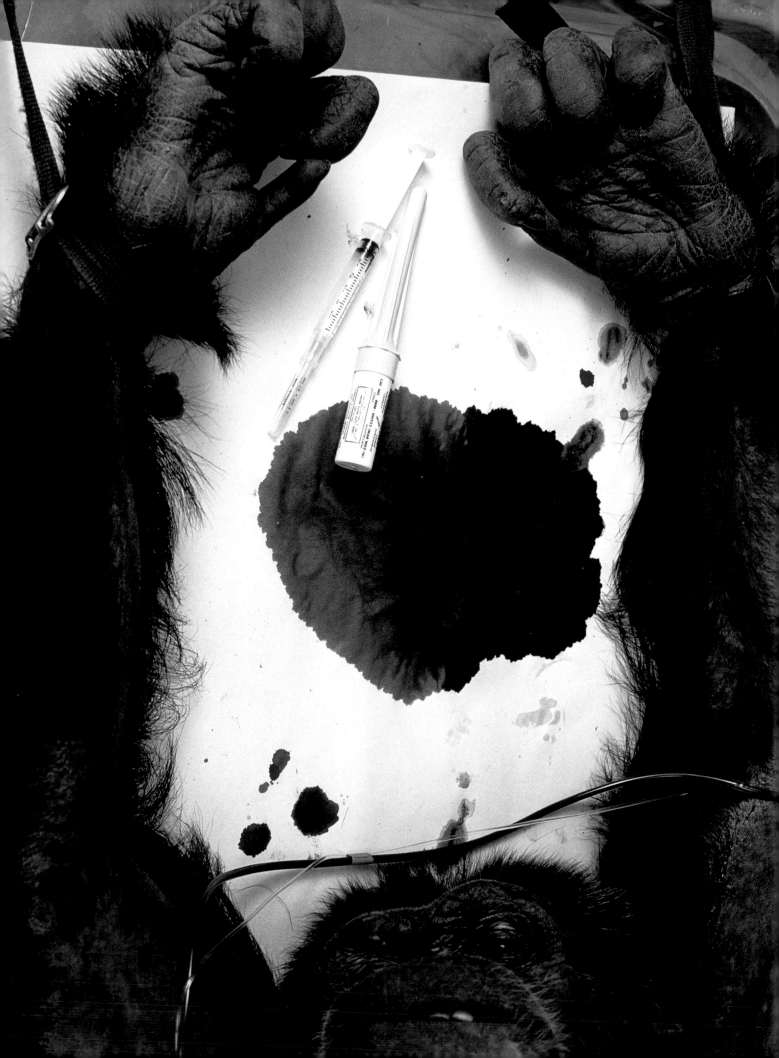

BRUTALKINSHIP

PHOTOGRAPHS AND TEXT BY MICHAEL NICHOLS

ESSAY BY JANE GOODALL

APERTURE

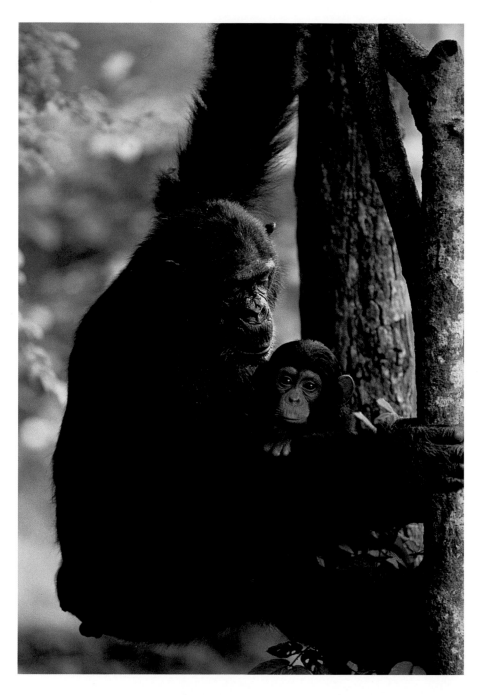

Page 10: At a medical research facility in New York, blood plasma separation is performed on one of its chimps. *Above*: Fifi tends to her baby Faustino. *Pages 14–15*: Lured into camera range with an audible decoy, this chimpanzees and his companions expected to feast on an antelope—but found a photographer instead. Most chimps would have fled in fear, but these individuals appeared too curious to run. They shrieked, hooted, threw sticks, and generally raised a ruckus, then settled down to watch. This could well have been their first contact with human beings.

CONTENTS

CHAPTER ONE IN THE WILD

TAI FOREST

On my first day out with scientist Christophe Boesch in the Tai Forest of the Côte d'Ivoire, we left the camp before daylight, setting off at a run into the forest. It was pitch black except for the flashlight beam hitting the mist. Boesch, who has been working in the Tai Forest since 1979, explained to me that if you don't get to the chimpanzees' nest before they wake up and leave, you can spend the entire day looking for them: vision in the rainforest is limited, and the chimps—at times very vocal—can also be stealthily silent.

When we reached the chimps, they were just dark shapes moving in their nests. Kendo, the group's alpha male, began hiking toward the boundary of his range. I followed Christophe, and he told me that he thought the chimps were going to hunt. He had heard the distinct sound of red colobus monkeys, the favorite prey of the chimps. And suddenly, everyone was gone. We chased them, and caught up just as the hunters had a colobus on the ground and began tearing it apart.

Christophe told me that the Tai Forest chimpanzees commonly share meat—more so than other groups of chimps—probably because of their great cooperation as hunters. They hunt strategically, he told me: some chimps will drive the prey while another group blocks the escape route, and still others wait in ambush.

The Tai Forest chimpanzees are a unique culture in that they use stone tools to open food. Stones are not common in the forest, and the chimps are able to relocate them each fruiting season and use them as anvils and hammers to crack open very hard coula and panda nut shells. Tai mothers teach their infants the skill of cracking the shells without crushing the kernels carefully and patiently—cleaning the anvil, putting the nut in just the right position, even molding the infants' fingers around the hammer, adjusting the lesson to the little one's level of skill.

Beyond the practical applications of their group behavior, chimpanzees, like humans, also interact to express emotion. For example, I believe that they are capable of mourning. During the short time I was in the Tai forest with Boesch, one chimp mother lost her baby. She may have let it wander too far out on a limb—it fell and broke its neck. The mother carried the baby's corpse around for three days, although it was rotting and smelling. Moments after the accident, chaos broke out among the other chimps in the group. Everyone wanted to touch the baby. Some of the baby's young playmates tried to make it join a game. The mother was plainly confused. She would set the infant down and walk away—but never more than thirty or forty yards—and then go back for it. By the end of the first afternoon, the little corpse already smelled. By the next day it was much worse. The group seemed to be getting back to its regular rhythm, but I saw other females come and sit with the mother. One brought her own baby, and the mother gently touched the live infant's body. At last, when the group was on the move, the mother of the dead baby dropped its body and went on a short distance. The others were already ahead, but looking back at her. She went back for the body and shook it—as if trying to wake it up—and then she set it down and left.

It is clear that scientific rigor would prevent a researcher like Christophe from concluding from an isolated case that this was an incident of mourning as we humans know it. But, as an informed although unscientific observer, I am convinced that the mother mourned her loss and that the other chimps were affected as well and tried to comfort her.

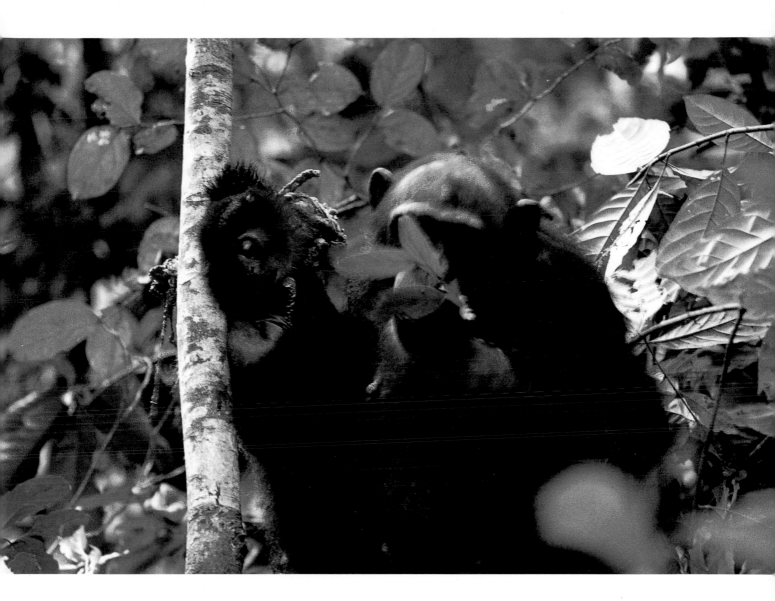

Above: An adult female chimp in scientist Christophe Boesch's study group in the Tai Forest, Côte d'Ivoire, eats her share—the head of a red colobus monkey. *Page 18 (top)*: Brutus, a chimpanzee in the Tai Forest, examines a dead colobus monkey that was killed and then dropped by an eagle. He gave the monkey's head to his favorite female and consumed the rest himself. *Bottom*: Wild chimps in Boesch's study group divide meat acquired during a collective hunt. The cultural structure of chimp populations varies according to region. *Page 19 (top)*: A Tai Forest chimp gnaws at the remnants of meat on a bone. *Bottom*: Boesch has discovered a tradition among Tai chimps of sharing fruit and other foods, which may have evolved out of the mothers' offering nuts to their young.

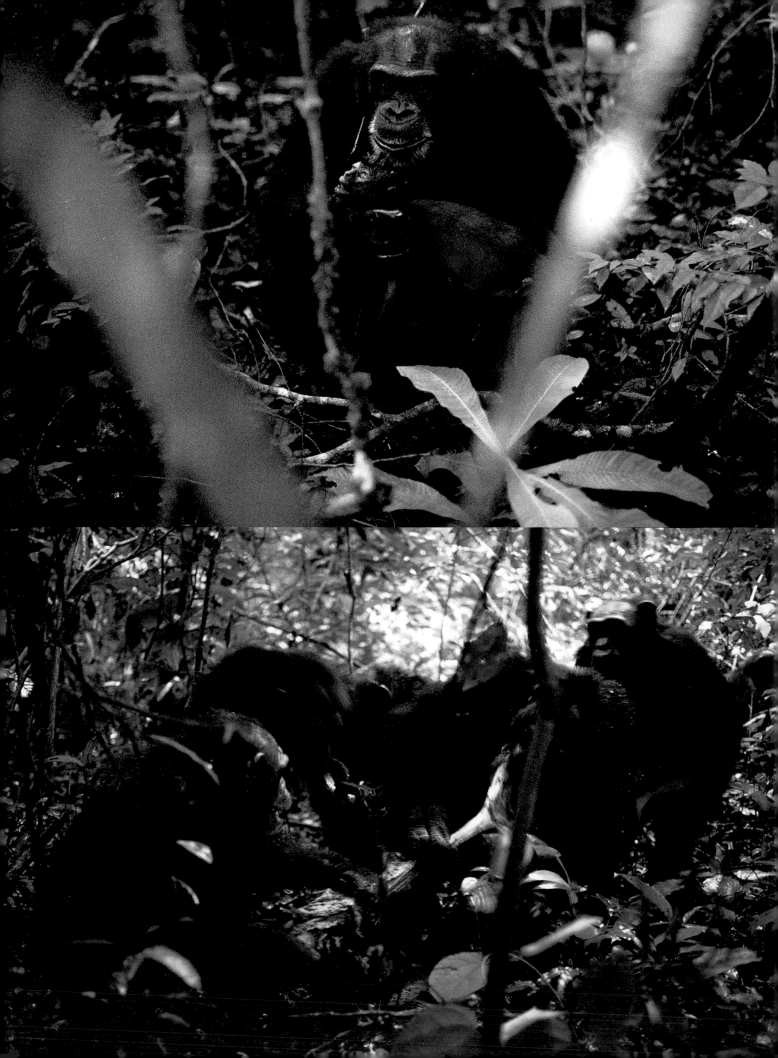

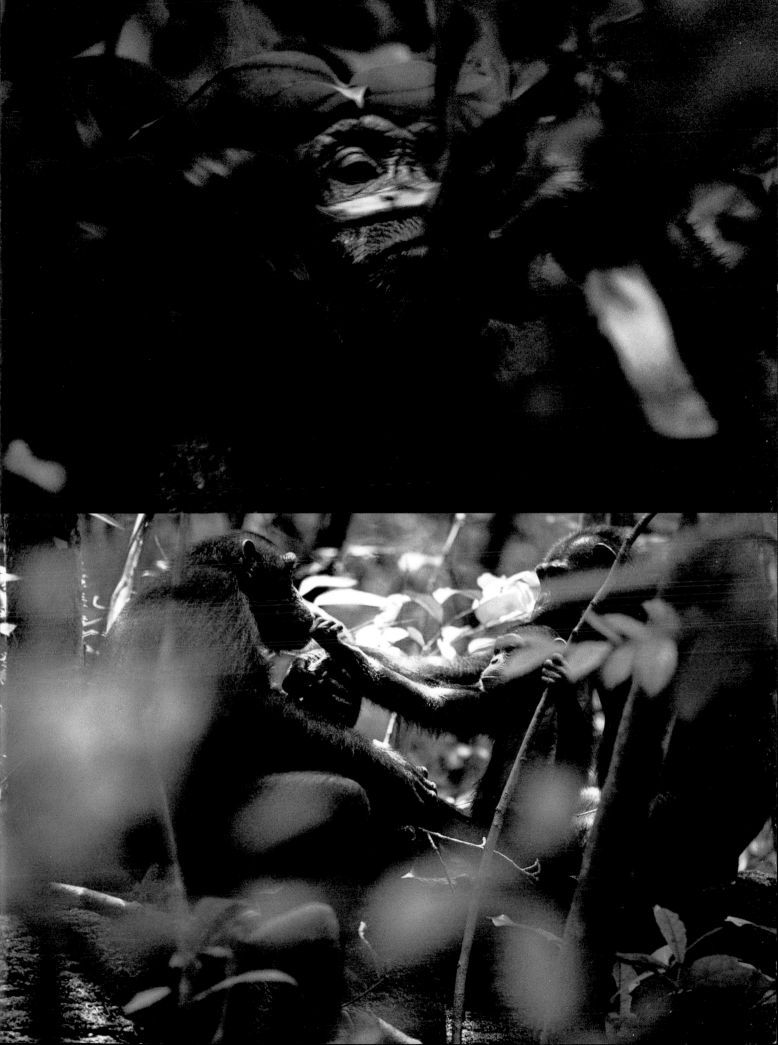

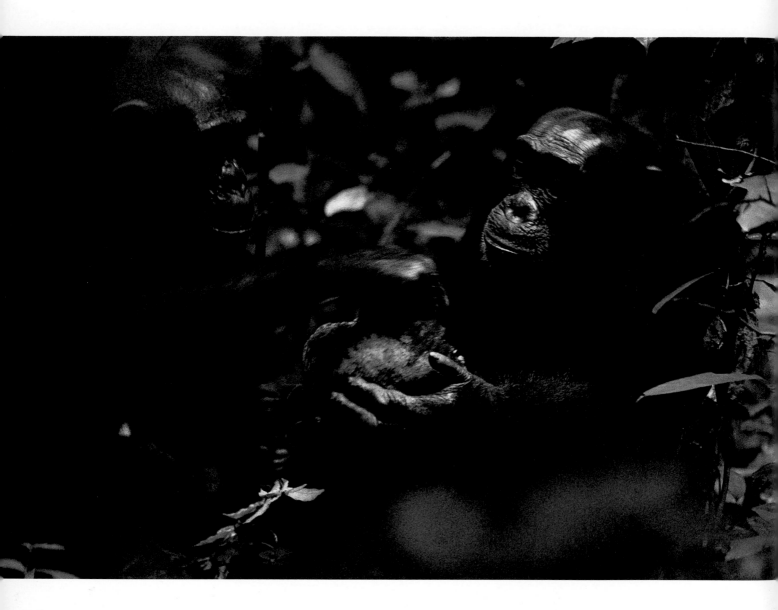

Above: Fruit collected in the Tai Forest is unselfishly shared by individuals, increasing social bonds in the community. *Opposite*: After the death of her own baby, this mother (also shown on pages 26 and 27) is allowed to touch the child of another female. *Pages 22-23*: In the Tai Forest, a female chimp in Boesch's study group demonstrates a skill once thought to be unique to humans. Here she is using a stone that she carefully selected to open a hard-shelled nut. The Tai Forest has few stones so Boesch has observed that the chimps must remember where they have left them. *Pages 24-25*: A male chimpanzee in the Tai Forest races through the forest in a drumming display. He will leap and repeatedly smack his feet and hands against the buttress roots of large trees to communicate his location and direction of travel to chimps scattered in the forest.

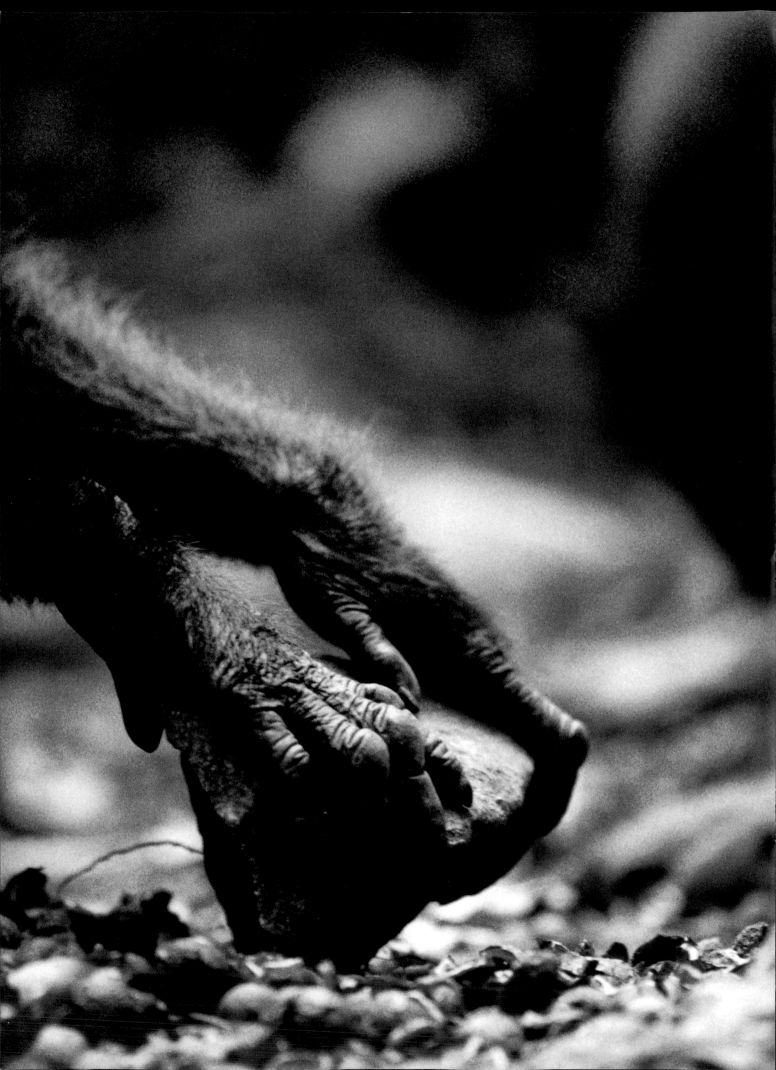

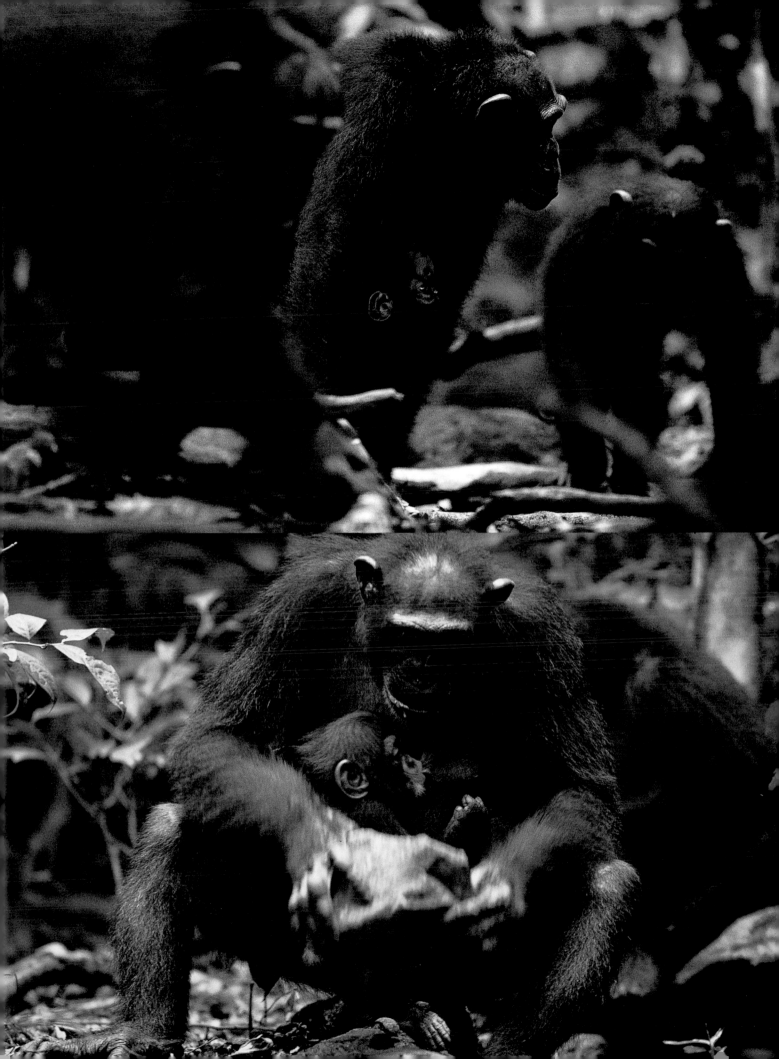

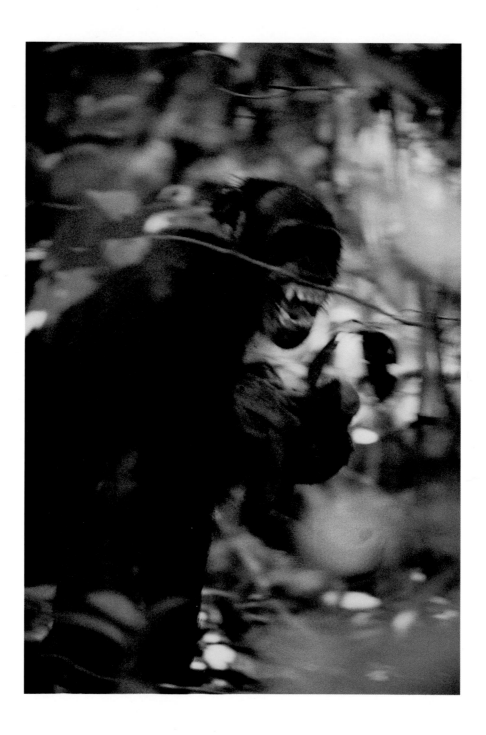

Above: With teeth bared, a female Tai Forest chimp protects the corpse of her infant. The first baby of this inexperienced mother fell from a limb, probably breaking its neck and sending the group into shrieking pandemonium. *Opposite*: For two days, the confused mother carried the body around before finally giving it a gentle touch and leaving it behind.

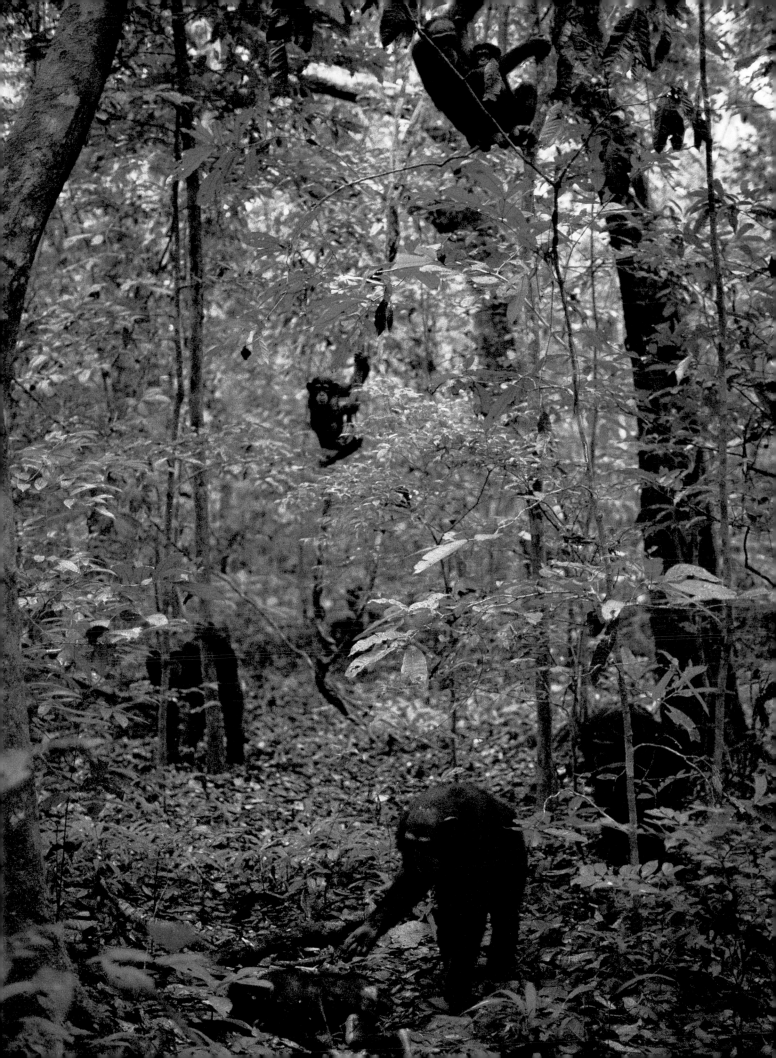

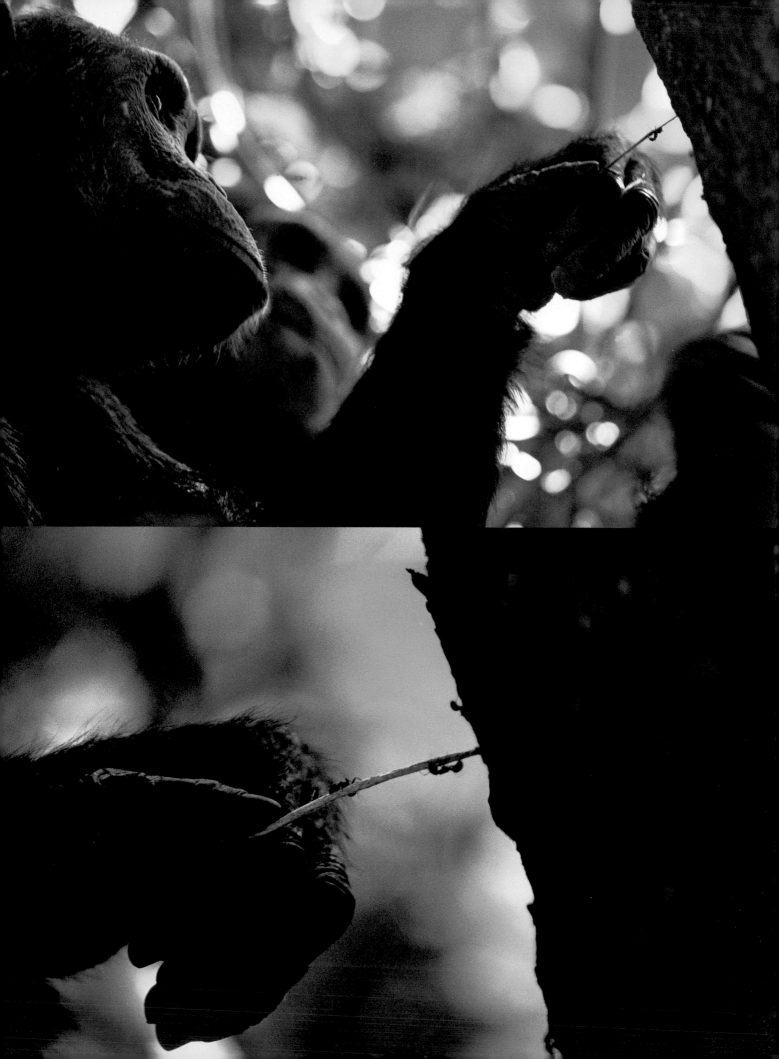

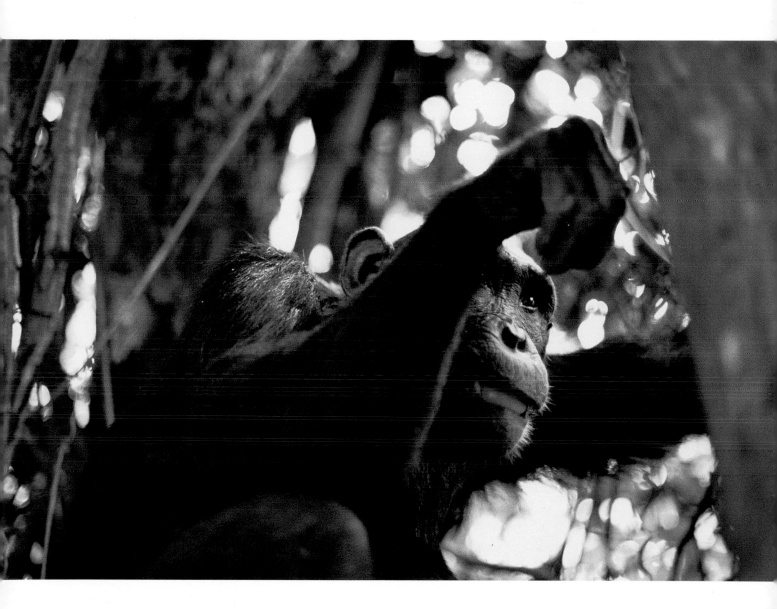

Chimps in the Mahale Mountains in Tanzania, the site of Toshisada Nishida's thirty-year study, fishing for ants. This is the most common tool use seen in Mahale. At the Gombe Stream National Park in Tanzania, in contrast, the most frequently observed tool use is fishing for termites with a twig.

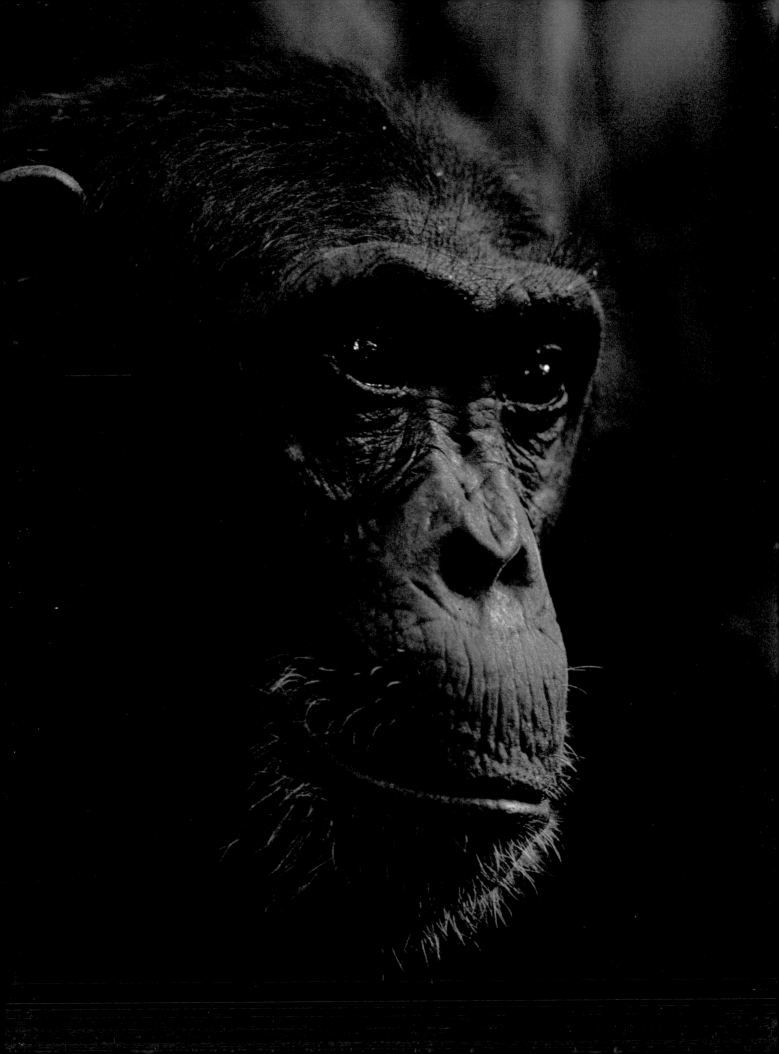

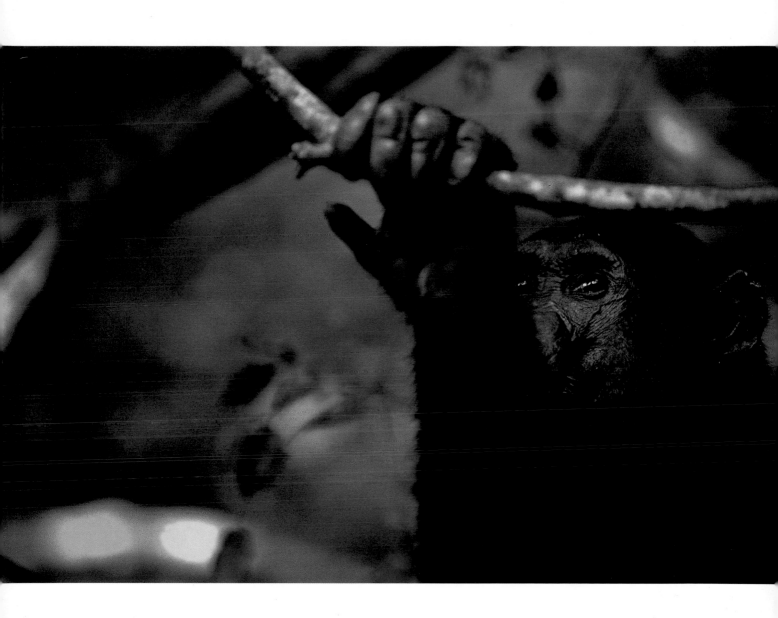

Above and opposite: Chimps in the Mahale Mountains National Park, Lake Tanganyika, Tanzania. *Pages 32-33*: Fifi's son, Freud, sleeps in the forest at the Gombe Stream National Park, Tanzania.

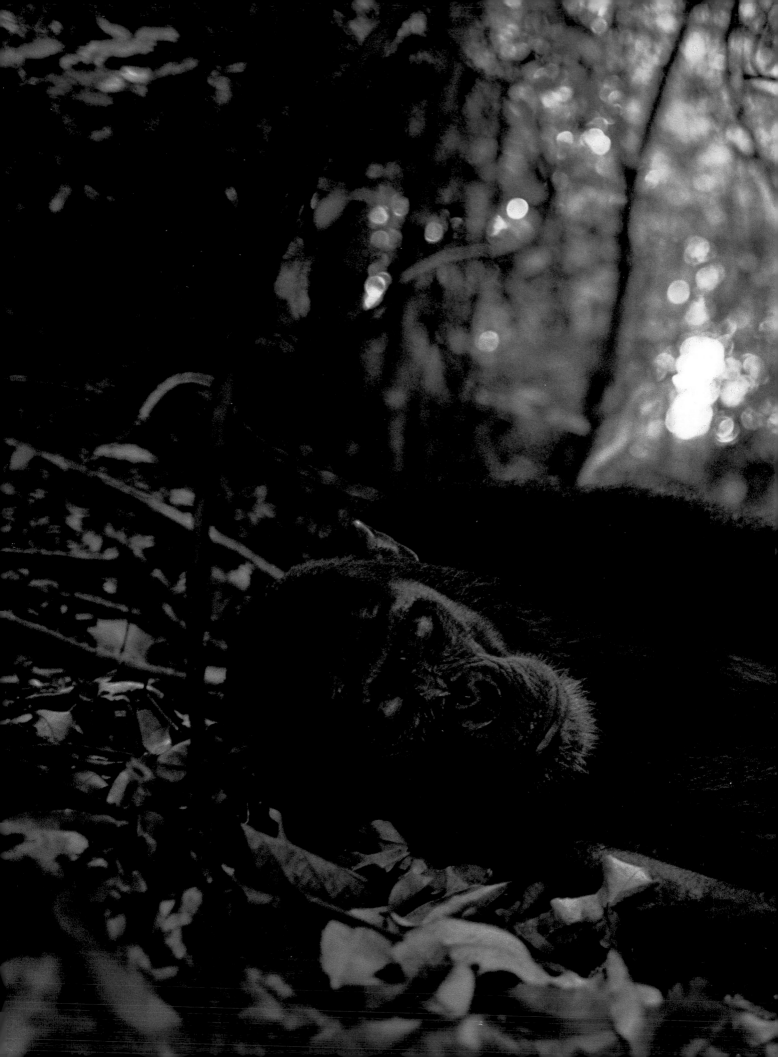

GOMBE

At the Gombe Stream National Park in Tanzania, Dr. Jane Goodall and her field assistants have been working for nearly forty years on what is now the longest uninterrupted field study ever undertaken of a wild species. The world's chimp population today is only 5 percent of what it was at the turn of the century. In the course of Goodall's research, it has become increasingly clear that the study and preservation of these animals in the wild is well worth substantial funding, time, and effort.

In the forest at Gombe the chimps were not traditionally hunted; with the continuing research, they see humans every day and do not fear them. The Gombe park is a very small island of habitat surrounded by humans voracious for land. Because the Gombe chimps are an isolated population, it has been calculated that their genetic diversity will reach a dead end in less than two hundred years.

In 1960, when Goodall first came to Gombe, it was a wilderness on the shore of Lake Tanganyika. Over the decades, the Gombe encampment has developed from the initial grouping of tents to a small village made up of Goodall's assistants and the staff of the park. Goodall has a simple house, hidden among the trees by the lake. There are huts for tourists who come through in inconsistent but substantial numbers to see chimps.

The Gombe terrain is very hilly open scrub, with areas of thorns and vines that are almost impenetrable to a six-foot human like myself with cameras hanging from neck and shoulders. The chimps, by contrast, are short, dexterous, and close to the ground; they glide quickly and easily through the tangle. Goodall, now in her sixties, wears plastic sandals on her feet, and yet moves through the scrub as effortlessly as the chimps. She carries only her notebook and a small camera.

Through Goodall's work and through the photographs and films of her first husband Hugo Van Lawick, I felt I already knew the original matriarch of the chimpanzee clan at Gombe—the famous Flo. When I first visited Gombe in 1989, Flo's daughter Fifi was carrying around her own infant, Faustino. At Gombe, there are three communities of chimps who are literally at war with one another over territory; of these, the Kasakela community has been the particular focus of long term research. I decided to focus on Fifi's family, hoping to show the strength of the bonds between them.

Besides Faustino, Fifi also has two adult sons, Freud and Frodo, who often travel together. These two became comfortable with my presence, sometimes even letting me doze next to them after they had worn me out moving through the terrain. Frodo, the younger of the two, has very aggressive tendencies however, so I had to be careful. According to Jane, he has been difficult from childhood. Adult chimpanzees are extremely strong: they can tear your arm off or worse. Frodo has a habit of knocking humans down and displaying on top of them. One time, while sitting next to

(continued on page 46)

Opposite: Ever the observer, Goodall joins a group of playful chimps, including longtime favorite Gremlin (reclining at center). Her Gombe study, begun in 1960, is the longest continuous field study of any animal in the wild. *Pages 36-37*: Wilkie was alpha male when this photo was taken. He attained this position after attacking and wounding the previous alpha, Goblin. They were fighting over access to a sexually attractive female. Several other males sided with Wilkie during the conflict.

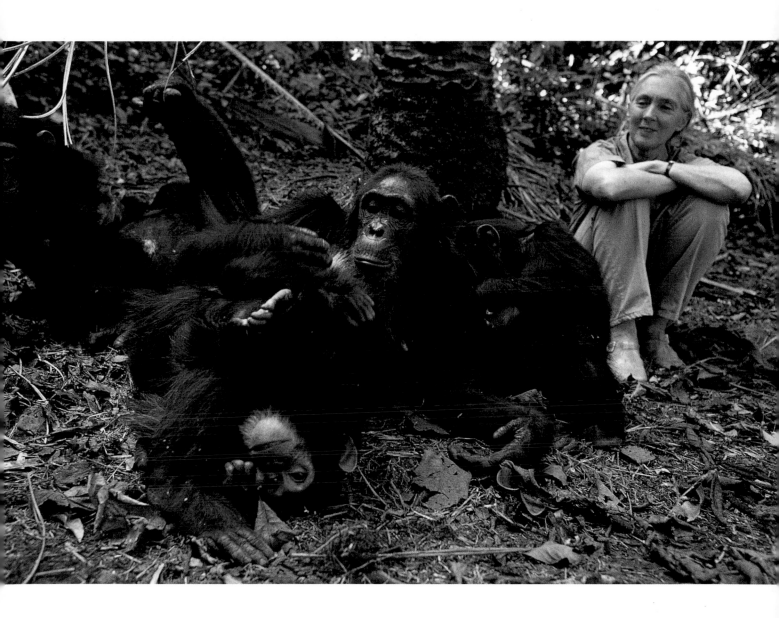

Page 38: Faustino, Fifi's son, at age six. *Page 39*: In February of 1995 one of the Gombe females, Rafiki, gave birth to twins, who were named Roots and Shoots. Multiple births are rare among chimpanzees—Rafiki's babies were only the third set of twins observed since 1960. *Pages 40-41*: A male chimpanzee displays as he swings through the forest of Gombe National Park.

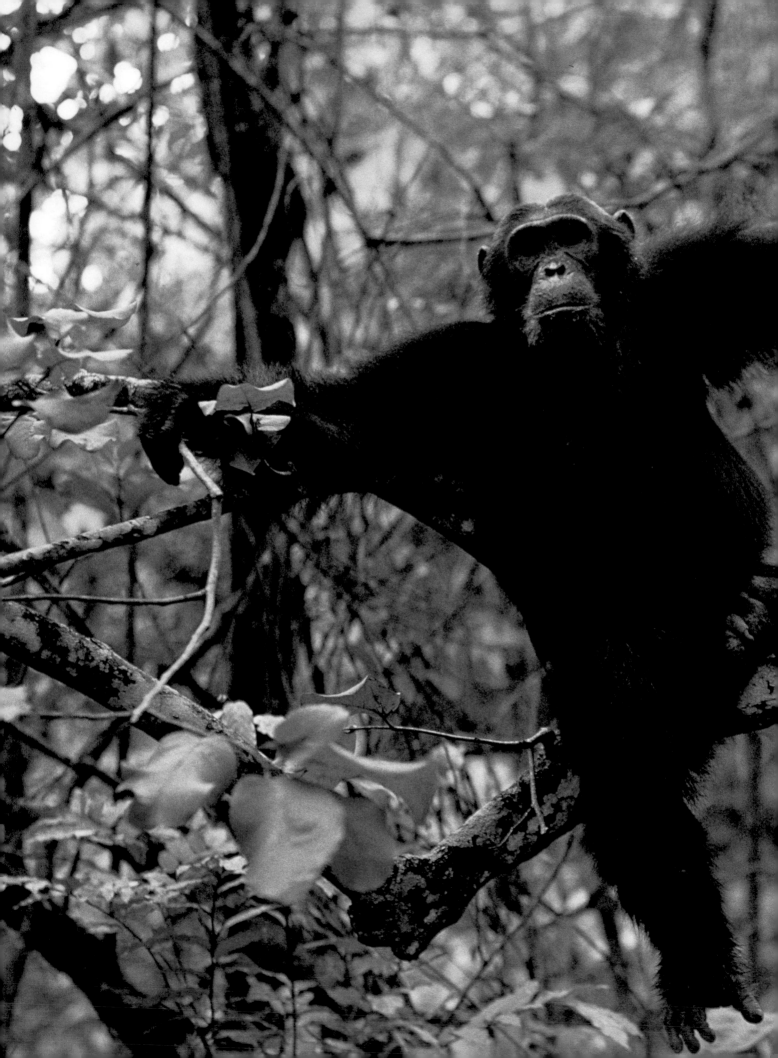

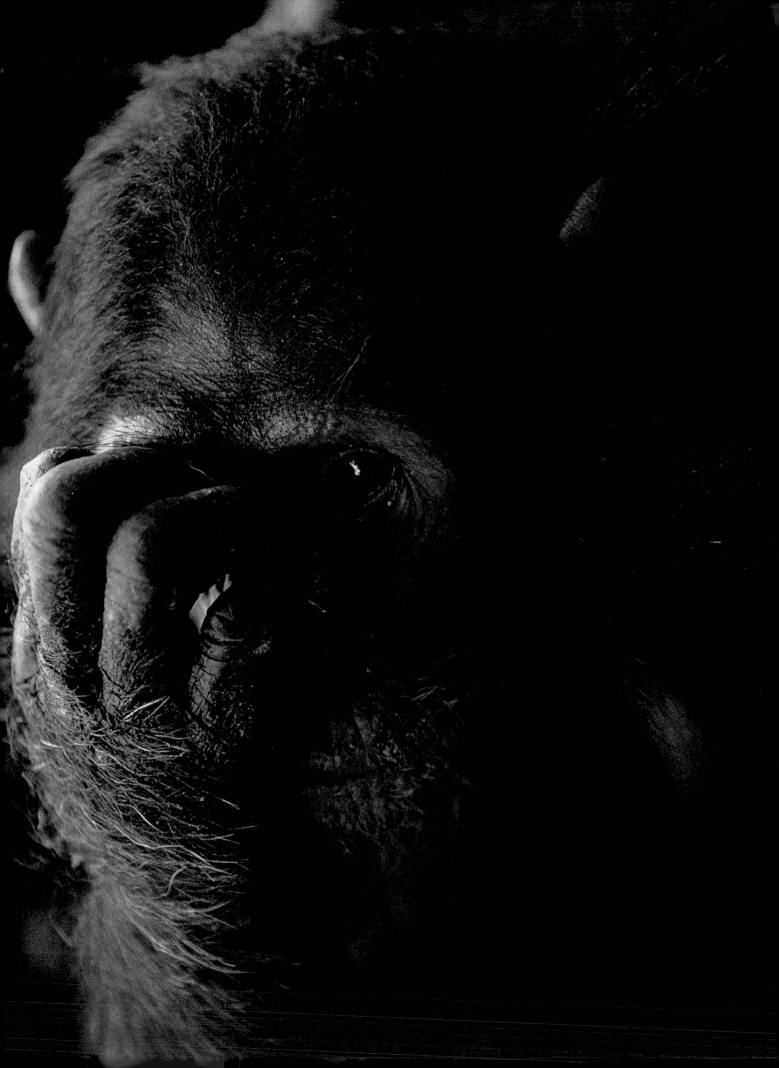

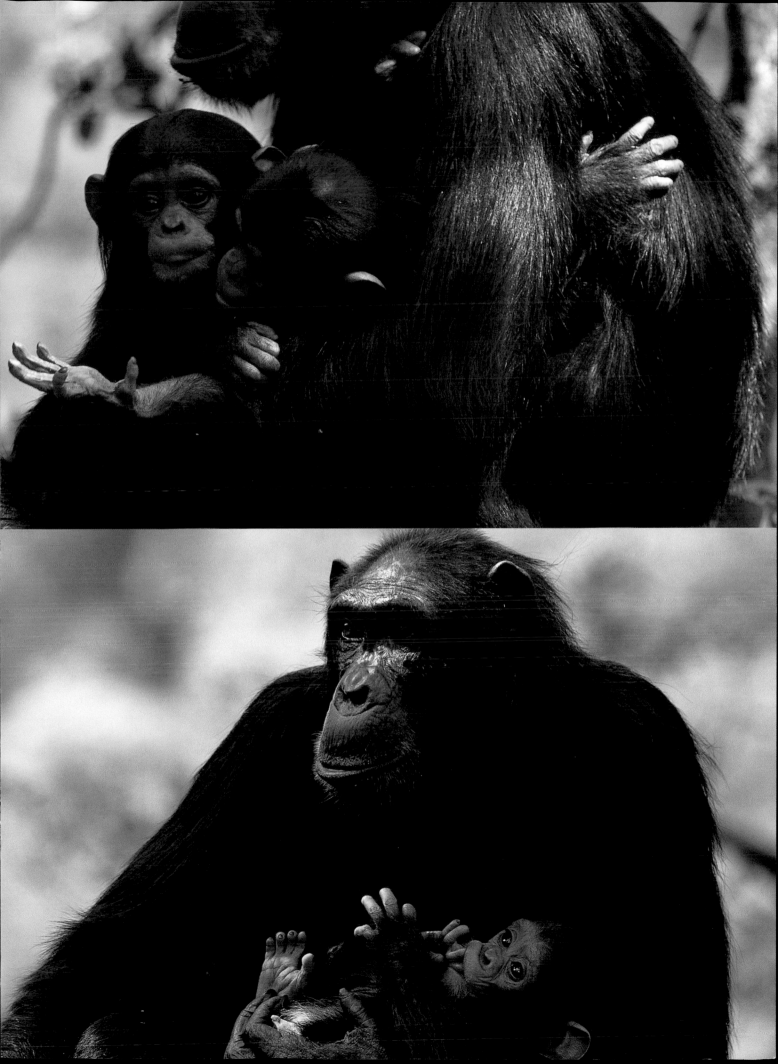

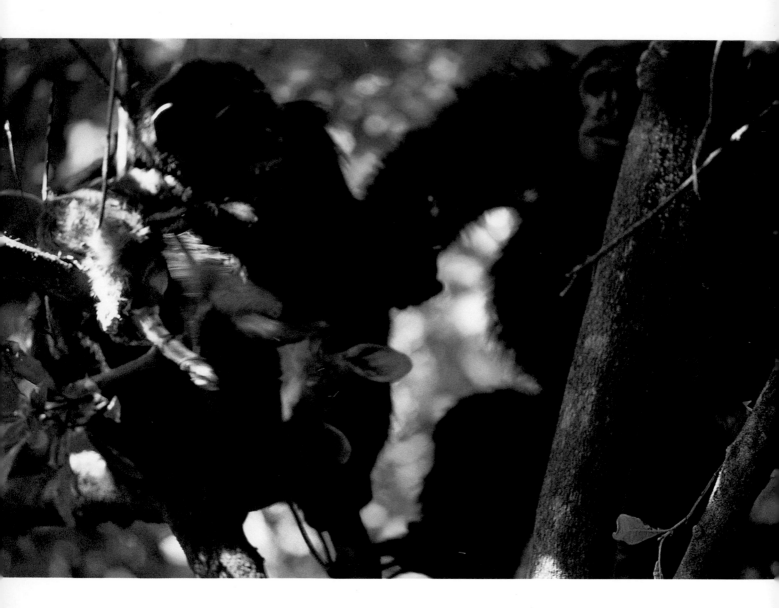

Above and opposite: After stealing a bushbuck from some baboons who had killed it, Fifi dominated the adult males in her group to keep the prize to herself. She did not share until hours later, after she was completely satisfied. The Gombe chimps, in addition to hunting, will take opportunities such as this one to eat meat. Meat eating by chimpanzees, long thought to be vegetarians, was Goodall's first major discovery.

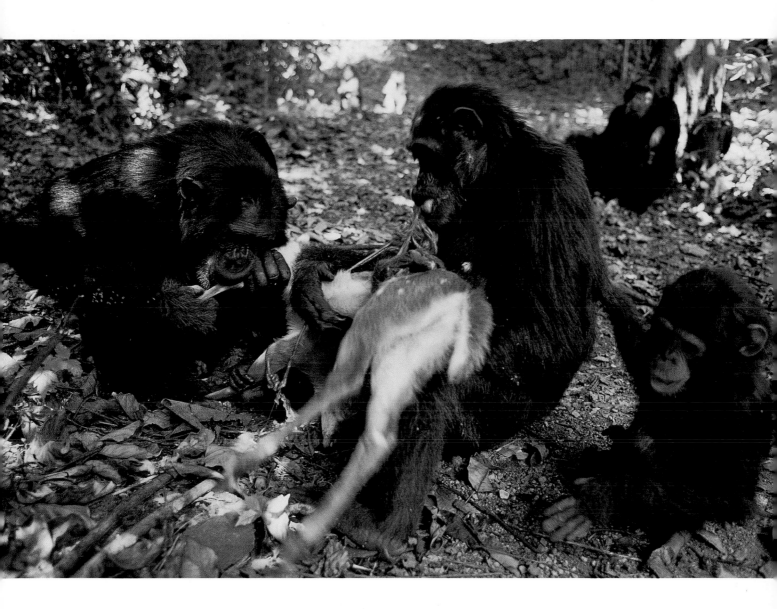

Page 44: Bill Wallauer, who follows the Gombe chimps from dawn to dusk, has a remarkable video record of the chimp culture. He speaks of the Gombe chimps as "we." He is shown here *(bottom)* with alpha male Freud. *Page 45*: After overthrowing his older brother Freud, Frodo became the current alpha male in this family of Gombe chimpanzees. Frodo is notoriously aggressive toward humans, but Goodall hopes that with maturity and leadership he might mellow.

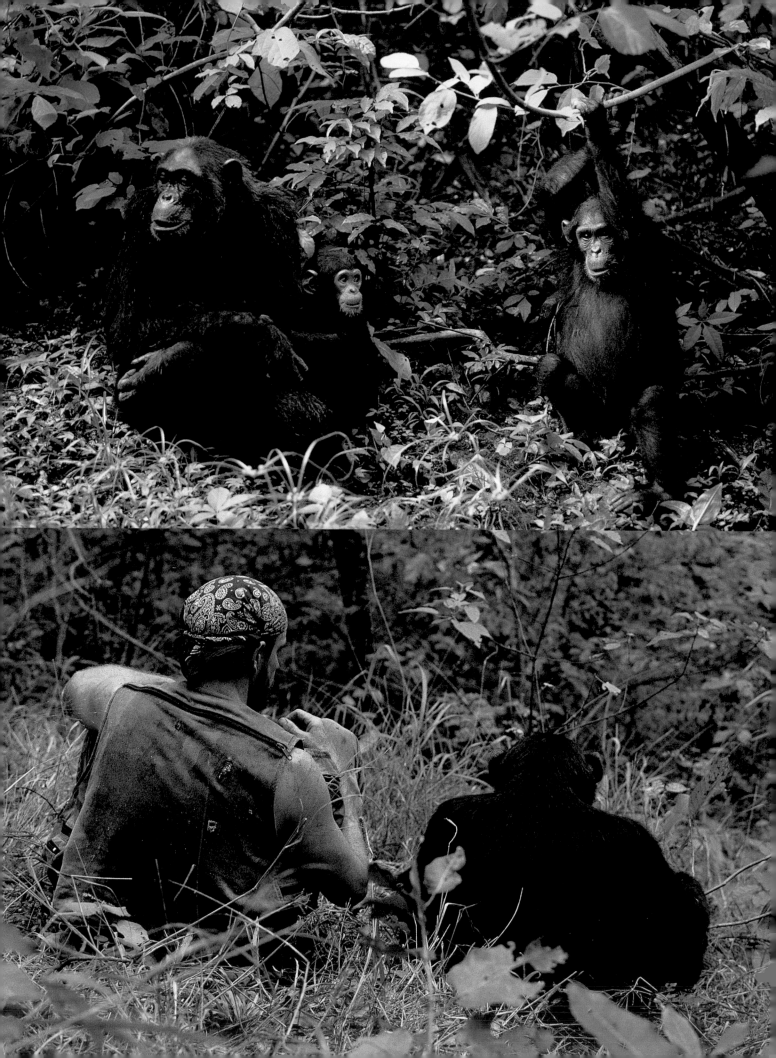

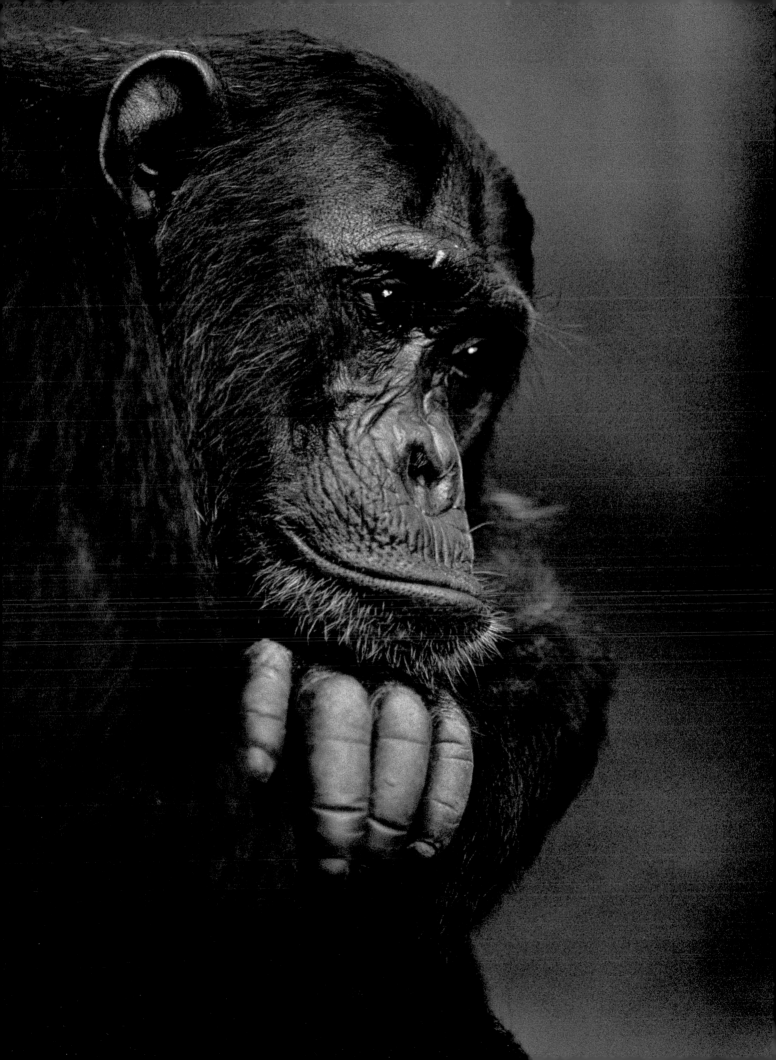

(continued from page 34)

Goodall and taking Frodo's portrait, he came up and grabbed me with a very solid grip. I curled up in a fetal position, and Frodo spun me around like a top. I was terrified that Frodo's aggression would only build and that he would cause me serious harm. Calmly, Goodall picked up her own camera and snapped a picture. The click of the shutter distracted Frodo, and he let me go.

Like her mother Flo, Fifi has a high rank in this group of chimpanzees. Fifi is passing this position to her sons, and she does things to push them along and to help them become more powerful. She has supported her sons in moving up the dominance ladder, and it is obvious that she herself is the dominant female of the community. In order to pave the way for Freud to become the group's alpha male, for example, Fifi even orchestrated an overthrow of Goblin, the machiavellian chimp who had been the dominant male in the mid- to late eighties. Jane Goodall's ongoing project of tracking these chimpanzees closely over the years, with mostly Tanzanian researchers, has produced amazing insight into chimpanzee behavior patterns and into the individual personalities and abilities of the chimps living in Gombe. It is clear that, as with humans, chimpanzee politics and interactions can be extraordinarily complex.

At Gombe, Goodall is in her element. She is constantly at work, both in the field and at home, and everyone needs and wants her attention. As I've gotten to know Goodall, I've seen that in addition to her field research, lecturing, and constant travel, she writes about thirty letters a day—to members of Congress or other people who might be able to help the cause of the chimpanzees and the environment. She puts the onus on everybody to do his part, and she knows the best way to do that is through personal contact, and that a handwritten letter from Jane Goodall might actually have an effect. The quality of her character is really astounding: it seems almost as if she doesn't eat or sleep, as if she lives on the pure force of her will. Of course she is still a human being—she's just extraordinarily strong.

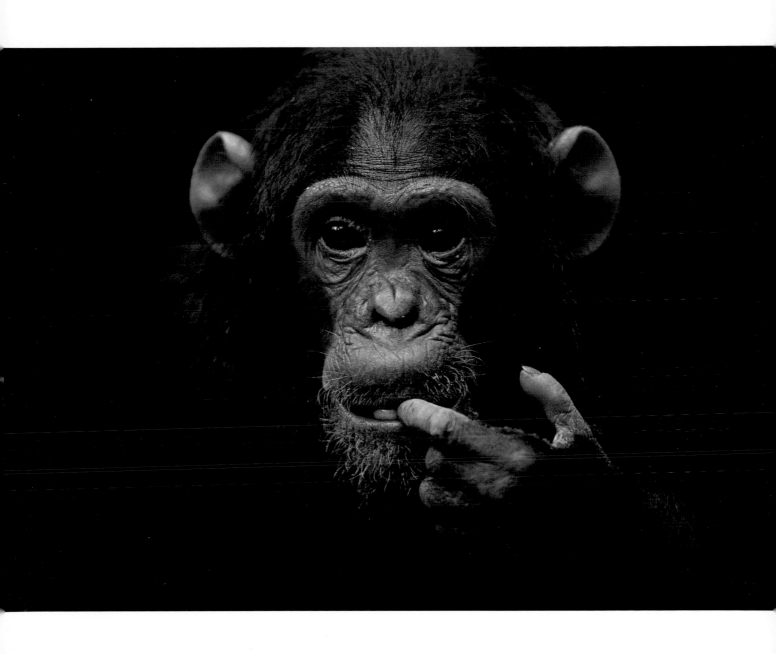

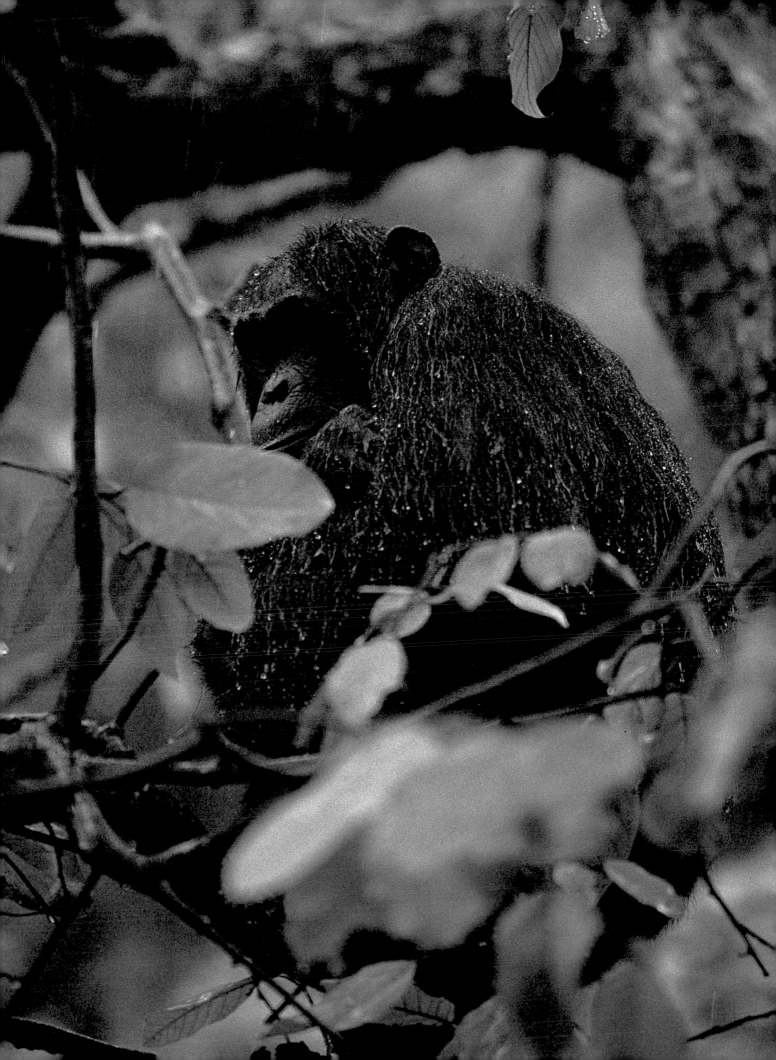

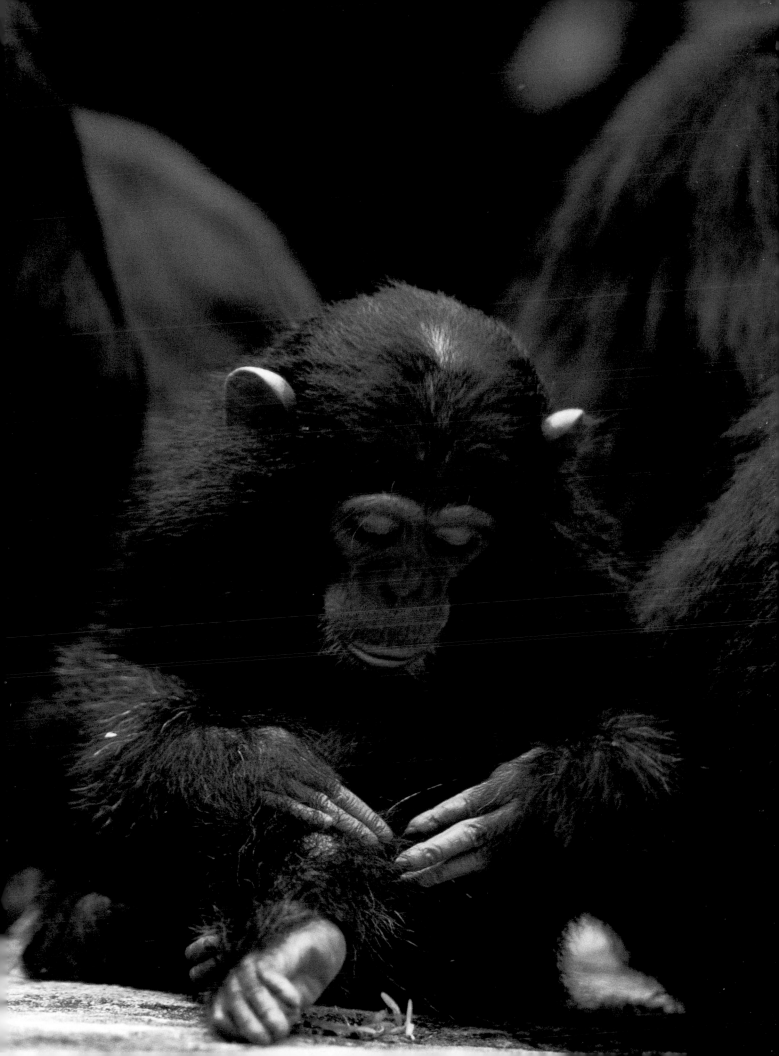

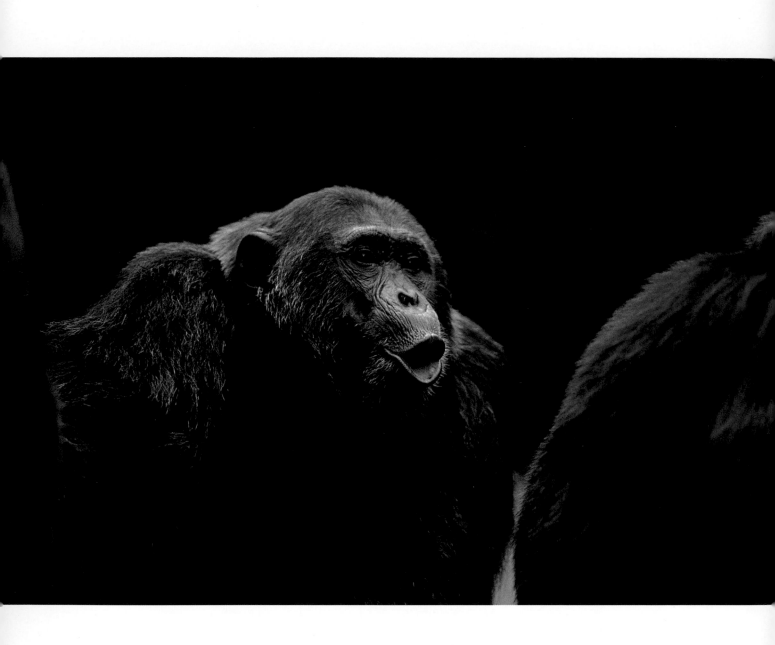

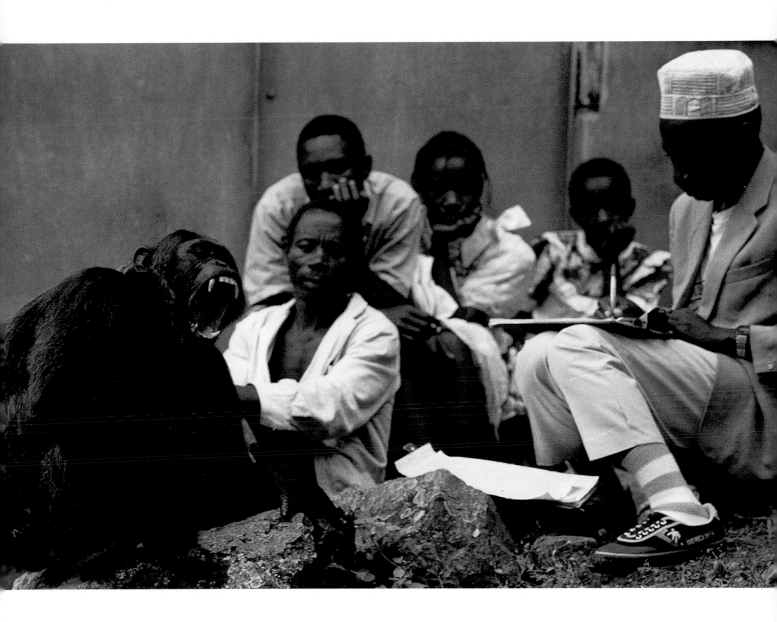

Opposite and above: Frodo hoots after hearing other chimps across the valley. Because Frodo has such an unpredictable personality, Goodall and the Gombe staff were concerned about his becoming the alpha male.

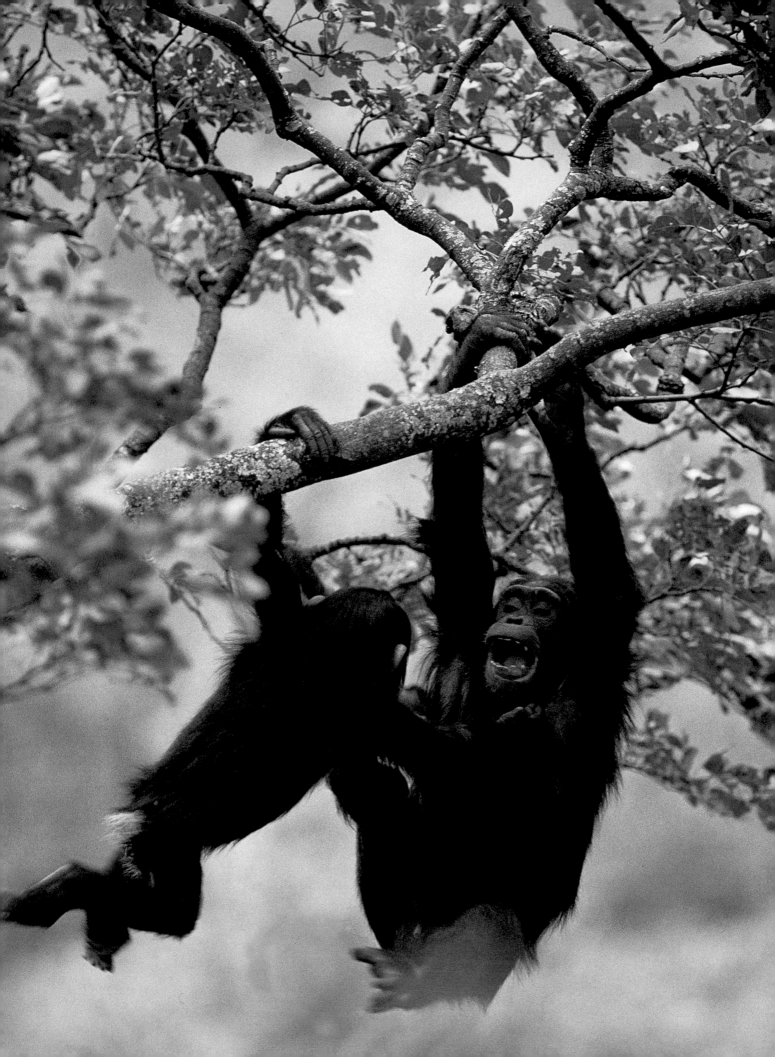

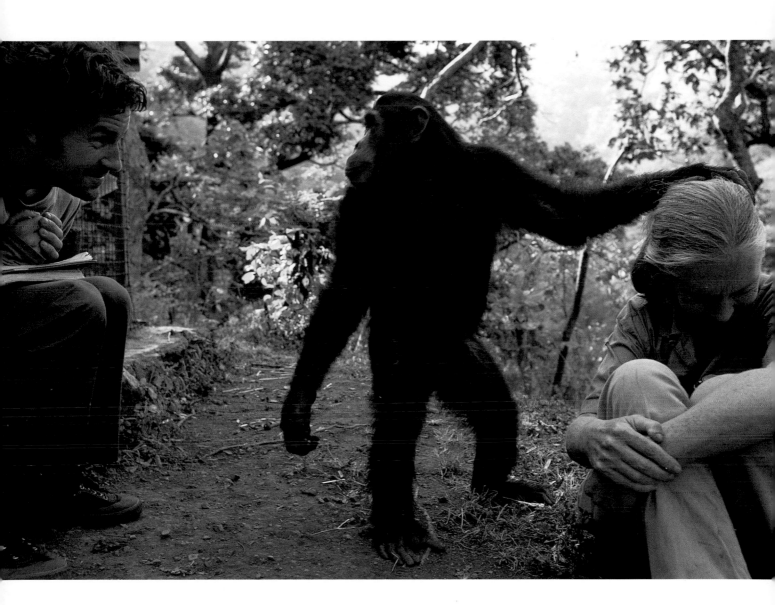

Opposite: Young chimps playing. *Above*: Meri (named after Goodall's longtime editor at *National Geographic*, Mary Smith) whacks Goodall playfully on the head. Meri's mother was one of the Kasakela females transferred from the Kasakela to the Mitumba community. Some of Goodall's students recently habituated the chimps of Mitumba with the hope of furthering their scope of knowledge from the Gombe study.

CHAPTER TWO JANE GOODALL

LAST YEAR I MADE MY FIRST VISIT TO SOUTH KOREA. AS I WAS WALKING ALONG A STREET IN Seoul, a young woman approached: "You must be Jane Goodall?" Her eyes filled with tears. "I never thought I'd meet you," she said. And then, "Please tell me, how is Fifi?" She had never left Korea but she knew of Fifi. I was amazed, almost in tears myself.

Fifi is the one chimpanzee who was alive when first I arrived at Gombe, Tanzania, in 1960 (she was about one year old then), who is still alive today. Her mother, Flo, was known to thousands—when she died, in 1972, she even had an obituary in the U.K. *Sunday Times*—and now that Flo is no longer with us, Fifi is surely the most famous of all wild chimpanzee females (David Greybeard being the most famous of all wild male chimpanzees).

Fifi has been studied throughout her life. I remember how utterly fascinated she was when her little brother Flint was born in 1964, always wanting to carry him or to rough-and-tumble and play with him. And then, when she reached adolescence, how absolutely preoccupied she became with the new experience of sex—so much so that I thought she was something of a nymphomaniac, and named her first child Freud.

Flo was still alive then; when she died, two years later, Flint was eight and a half years old, theoretically quite capable of looking after himself. But he had become so abnormally dependent on his old mother, and was so shattered by losing her, that he went into a depression, fell sick, and was dead within the month. Fifi, however, got more and more powerful, along with other members of the "F" family. Her eldest brother, Faben, lost the use of one arm during a polio epidemic, but nevertheless developed a magnificent upright charging display. Then he formed a close alliance with his young brother Figan, who went on to become the most powerful male the community has known in thirty-seven years. Fifi's firstborn, Freud, was at an impressionable age when his uncle reigned supreme, and eventually became alpha male himself, about twenty years after Figan's ten-year reign.

Between 1971, when Freud was born, and 1998, Fifi has given birth to eight offspring, five males and three females. The first four are already fully sexually mature: indeed Fanni has produced two grandsons—Fax (who died) and Fudge; and Flossi has produced one grandson—Forest. Fifi is thus the most reproductively successful of any Gombe female. She is also, as Flo was, an excellent mother, attentive, supportive, and playful. And also like Flo, she is high ranking and assertive, thus giving her offspring a good start in life.

Only after the birth of Fifi's seventh child, Fred, in 1997, did tragedy strike: an epidemic of sarcoptic mange (scabies) swept through the Gombe population, causing terrible

Opposite: Goodall with Gregoire, a chimp who had been alone in a dark cage in the Brazzaville Zoo in Congo since 1945. When Gregoire was brought to Goodall's attention in 1988, he was completely hairless, losing his sight, and starving. Today he is housed in one of Jane Goodall's sanctuaries with two young chimpanzees and two adult females and has an outdoor exercise play area. This photo was taken in his old cage where the door had actually sealed itself shut with rust.

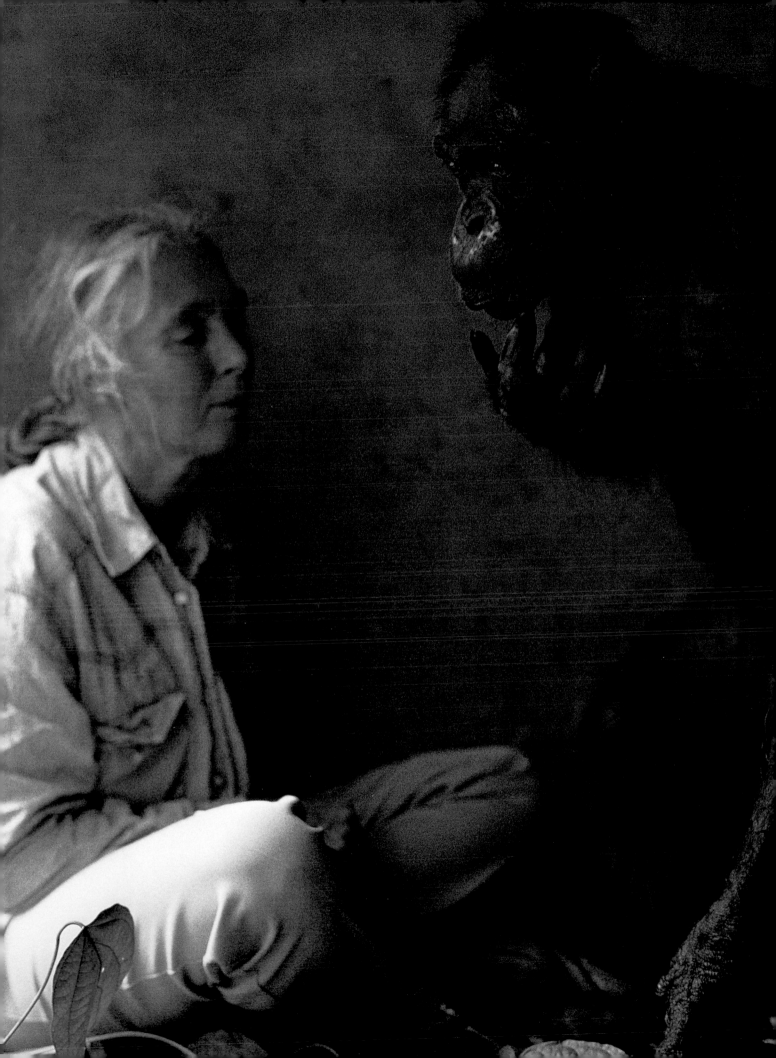

itching and hair loss in those affected. Even though the Jane Goodall Institute (JGI) provided medication to all, Fifi herself became almost completely bald, and Freud and his younger brother Ferdinand also became sick, as did Fanni and tiny Fudge. Little Fred died of the disease. Freud lost more than half his hair, and also lost his top-ranked position to his younger brother Frodo, who was not affected at all. So Frodo—the bully, the rogue male who flings humans to the ground, sometimes stamping on them and dragging them—is at the time of writing (October 1998) the new alpha male.

Chimpanzees, along with bonobos, are the apes that have the closest biological relationship with our own species. In DNA structure they differ from us by only a little over 1 percent. The anatomy of their brain and central nervous system is more like ours than is that of any other living creature, and there are also similarities in the immune system and the composition of the blood. The consequence is that chimpanzees can catch or be infected by all human infectious diseases and that some scientists see their living bodies as ideal testing grounds for potential cures and vaccines for illnesses like AIDS and hepatitis.

If the physiological similarities between chimpanzees and humans cause our disease patterns to follow a similar course and be affected by the same preventative or curative agents, then similarities in our brains and central nervous systems should mean, logically, that there would be similar behavioral, intellectual, and emotional patterns. Chimpanzees cannot talk, at least not with vocal cords, mouths, and tongues. But in captivity they have been taught 300 or more of the signs of ASL, the American Sign Language used by deaf people. And they can also learn to communicate by identifying, sometimes on computers, the symbols or lexigrams of specially designed artificial languages. These sophisticated captive chimpanzees, like the famous signing Washoe in Washington State and the extraordinarily intelligent Ai ("Love") in Japan, have proved that they can understand and use abstract symbols in their communication, and that they understand the moods and recognize the needs of others. Chimpanzees can identify themselves and companions in pictures or mirrors. They have a concept of self.

Over the years of research at Gombe, we have come to know so many vivid personalities, each one unique. We have recorded life histories, family histories, and the history of a community. From the chimpanzees we have learned just how like us they are. Gestures they use for communication are sometimes uncannily like ours, not only in form but also in the contexts in which they occur. When friendly individuals meet after a separation they may fling their arms around each other, hold hands, pat one another on the back, kiss. If they are suddenly frightened or excited they may reach out to touch or embrace. If they want a share of another's food, they beg, palm up. When they play, they laugh and tickle one another; when angry, they swagger and shake their fists. After an aggressive incident the victim may approach and crouch in appeasement, or hold one hand toward the aggressor: this sign of submission typically elicits a reassuring touch or pat, restoring social harmony.

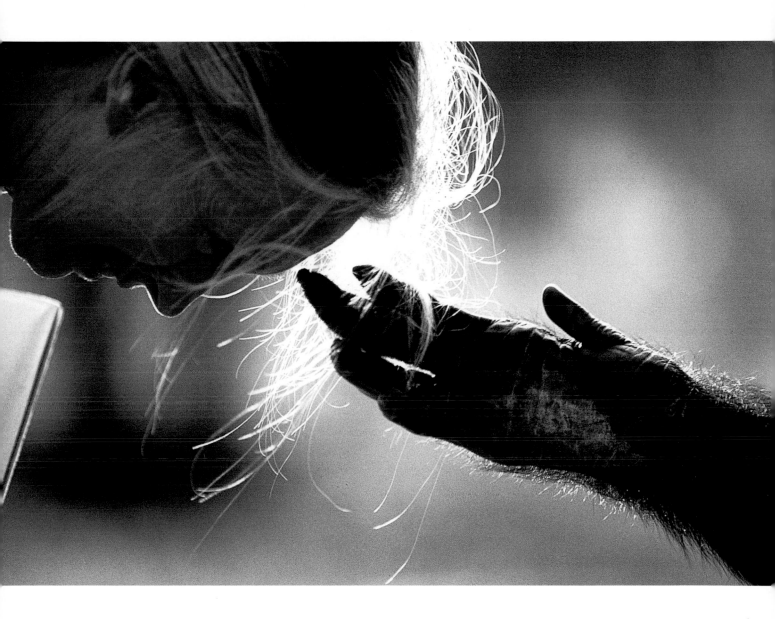

Above: The touch—an exquisite moment for Goodall—came when Jou Jou, a full-grown male chimpanzee reached his hand out to her in greeting. He had been caged alone for years in the Brazzaville zoo; a social animal, he was desperate for contact with other living beings.

Bonds between family members are strong and enduring. When a new baby is born, the older child, who will be at least five or six years old, remains closely attached to the family for at least the next three or four years, and will continue to spend time with the mother throughout his or her life. Thus friendships develop between maternal siblings, and become stronger between mother and child. Chimps do not mate for life, and there is no father-child relationship as such; the mother raises the children. But males may show well-developed "paternal" skills when the situation arises. When a mother dies, for example, her infant may be cared for by an older brother just as effectively as by an older sister. Males also patrol the boundaries of the community territory and protect its resources for their females and young.

As well as observing instances of caring and even altruistic behavior among chimpanzees, we have found that, just like humans, they have a dark side to their nature. They are capable of brutal aggression, particularly during intercommunity conflicts, which sometimes resemble primitive warfare. But I do not think chimpanzees are capable of evil because I do not think they fully understand the effect of their behavior on others.

We cannot prove that chimpanzees experience emotions similar to those we attribute to ourselves—joy, sadness, fear, despair, and so on— but anyone who has spent time with them knows that they do (just as we know dogs and other animals do, no matter what some scientists say). An infant chimpanzee has the same need for comfort and reassurance as an infant human. Flint was one of several orphans who died from grief after losing his mother. Chimp as well as human youngsters, when full of *joie de vivre*, will gambol around, somersault, pirouette, and sometimes break off to hug their mother in sheer exuberance. Chimps have a sense of humor, and they can also be embarrassed.

Chimpanzees are very much more intelligent than anyone used to think—indeed their minds are more like ours than some people want to believe. Wild chimpanzees use tools and even make them. At Gombe, nine different tool-using traditions are in common use. One kind of tool use is that of grass stems or twigs stripped of their leaves to fish for termites; long straight sticks are peeled of their bark, making the stick smooth and therefore easier for the chimp to push into a passage in the termite mound. After a pause the stem or stick is withdrawn, carefully, so as not to dislodge the insects that have gripped the tool with their mandibles. Any soldier termites are picked off with the lips and chewed. Two other examples of tool usage are crumpled leaves used as sponges to soak water from hollows in tree trunks and rocks used as missiles. And wherever chimps have been observed in Africa, they show a different set of tool-using behaviors—traditions passed from one generation to another through observation, imitation, and practice. Chimpanzees in West Africa, for example, use rocks or hard pieces of wood to crack open nuts and hard-shelled fruits, but we've never yet seen this use of hammer and anvil in Gombe or any other East African chimpanzees. In fact, we can describe these traditions as primitive cultures.

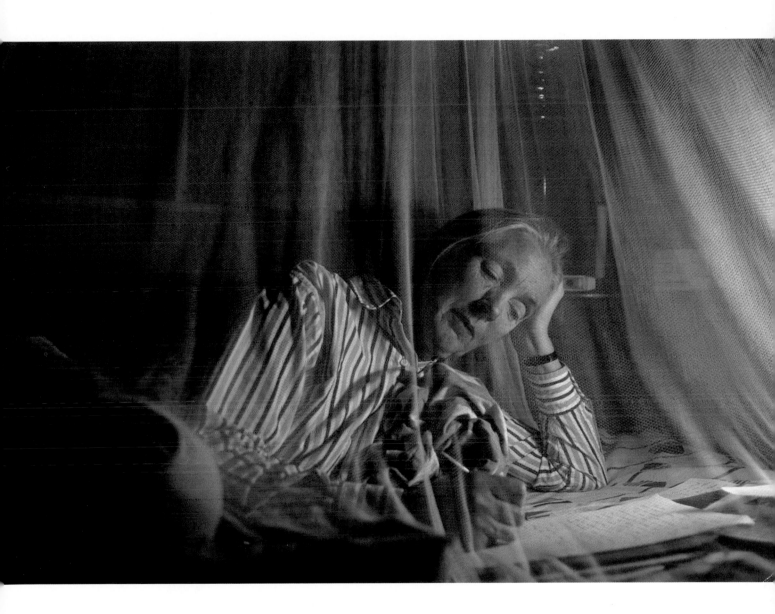

Goodall, in her home in Dar es Salaam, Tanzania writes twenty to thirty letters a day in an effort to further her goals of protecting chimps and their habitat and of making the world a better place for all living beings. She has a talent for making individuals realize that what they do can make a difference. The force of her personality makes it impossible to say no.

In the wild, chimps need to be intelligent to operate efficiently in their highly complex society. They've got to know the personalities and judge the moods of those around them at any given time. And they need to understand the relationships between their companions, which are likely to affect what they can and cannot do. Community members make alliances, and it is unwise to threaten an individual whose ally is nearby and is higher ranking than you are. Chimps may get their way by distracting others' attention, by withholding information, and even by lying. An infant who is being weaned, but who wants to ride on its mother's back, may suddenly "see" something frightening in the undergrowth, stare, and scream; it will then be allowed to ride. But there may be nothing in the undergrowth at all!

A few years ago Michael "Nick" Nichols visited me in Gombe. We followed Fifi and some of her offspring and watched in amazement as she seized and killed a bushbuck fawn and protected her kill from the swaggering assault of an adult male. (The blood of old Flo indeed runs true in her daughter.) We spent time with the brothers Prof and Pax; their mother had died when Pax was just four years old, and Prof had become his caregiver, protector, and comforter. Sitting on the beach in the evening, as the sun set over the crystal-clear waters of Lake Tanganyika, we re-lived special moments of our day in the ancient forest: Prof, feeding high in the canopy, had misjudged the strength of a branch and fallen, plummeting some twenty to thirty feet. Fortunately he had managed to save himself, grabbing a mass of tangled vines just fifteen feet above the ground. And little Pax, who had been quietly feeding in a nearby tree, had clambered over to sit close to his brother, peering into his face, concern radiating from his small body, while Prof had remained quite still as though dazed, shocked. Eventually, after some grooming, they had started to feed again.

I remember Nick saying, "They're just so like us, it's crazy!" And I said something like, "Isn't it almost impossible to believe that people treat them the way they do, in the medical labs, in circuses, in entertainment." We talked about the grim facts, the problems faced by chimpanzees everywhere, in their natural habitat as well as in captivity. At Gombe the chimpanzees are protected by the Tanzanian government, but most wild chimps are less fortunate. Their forests are being destroyed. They are being caught in snares and shot for food. Babies are being stolen from their dead mothers for the live-animal trade, destined to be dressed up in inappropriate clothes as surrogate children for lonely people, pets behaving like subhuman infants. Or to be chained by the neck as decoys to attract customers to African bars or hotels. Some, shipped illegally overseas, are subjugated to the harsh, often brutal, and always demeaning training that will create performers for the circus, for advertising, for picture postcards. Some end up in five-by-five-foot steel prisons in medical labs, where their living bodies are injected with human infectious diseases.

As I was starting my research at Gombe, a little chimpanzee, born in Africa, was making history in the United States: Ham, the first astronaut chimp, paved the way for the first human astronauts, including John Glenn, who is making history again with a space flight at seventy-five years old. NASA trained a number of chimpanzees to operate the complicated controls of space capsules—incredibly rigorous training, which must have been horribly stressful. Then, as the role of chimps in space research diminished, the U.S. Air Force deployed this same group of chimpanzees in other ways, allowing pharmaceutical companies to use their bodies for hepatitis and AIDS testing. This was profitable and the colony grew, until, by the early nineties, there were well over a hundred. And then it turned out that chimps were not useful for AIDS research, for although they could be infected with HIV, the retro-virus that causes AIDS, they didn't seem to contract AIDS. The Air Force no longer wanted them and decided to divest itself of what had become a costly burden. There was an attempt to hand them over, quietly, to one Frederick Coulston in New Mexico, already the owner of more than 650 chimpanzees. But as Coulston, a toxicologist, has many charges of violating the Animal Welfare Act in his file, a coalition of animal-welfare and animal-rights groups tried to raise the money to outbid Coulston and to provide a sanctuary where these unfortunate chimpanzees can live out their lives. The Air Force gave 111 of the chimpanzees to Coulston for permanent ownership. Only thirty were granted reprieve and given to a sanctuary in Texas.

And so we sat there, Nick and I, surrounded by the utter tranquillity of my Gombe paradise but plunged, by our thoughts, into a very different world, a world of steel bars and heavy chains, beatings and painful medical procedures, solitary confinement and taunting, jeering crowds of ignorant people. A nightmare world that was stark reality for thousands of chimpanzees, and from which most would never escape. What could we do about it, Nick and I and all the others who cared?

We could at least try to make more and ever more people aware, wake them from apathy to an understanding of the grim reality. Nick with his photos, me with my writing and speaking. And so the idea for *Brutal Kinship* was born, part of our commitment to chimpanzees everywhere who are incarcerated, tortured, and exploited, in part because of the kinship of our two species.

To obtain the pictures Nick had to steel himself to spend time with some of the chimpanzee victims. To get firsthand information I had to do the same. During the two years after our talk in Gombe, we shared many harrowing experiences. There was the pathetic infant chimpanzee offered for sale in a tourist market in Central Africa—the first I saw

Pages 64-73: In the sixties, chimps were used as surrogates for people by the Air Force and NASA in developing the space program. Photos courtesy of the Hangar 9 Museum, Edward H. White II Memorial / Museum of Flight Medicine, Brooks Air Force Base, Texas.

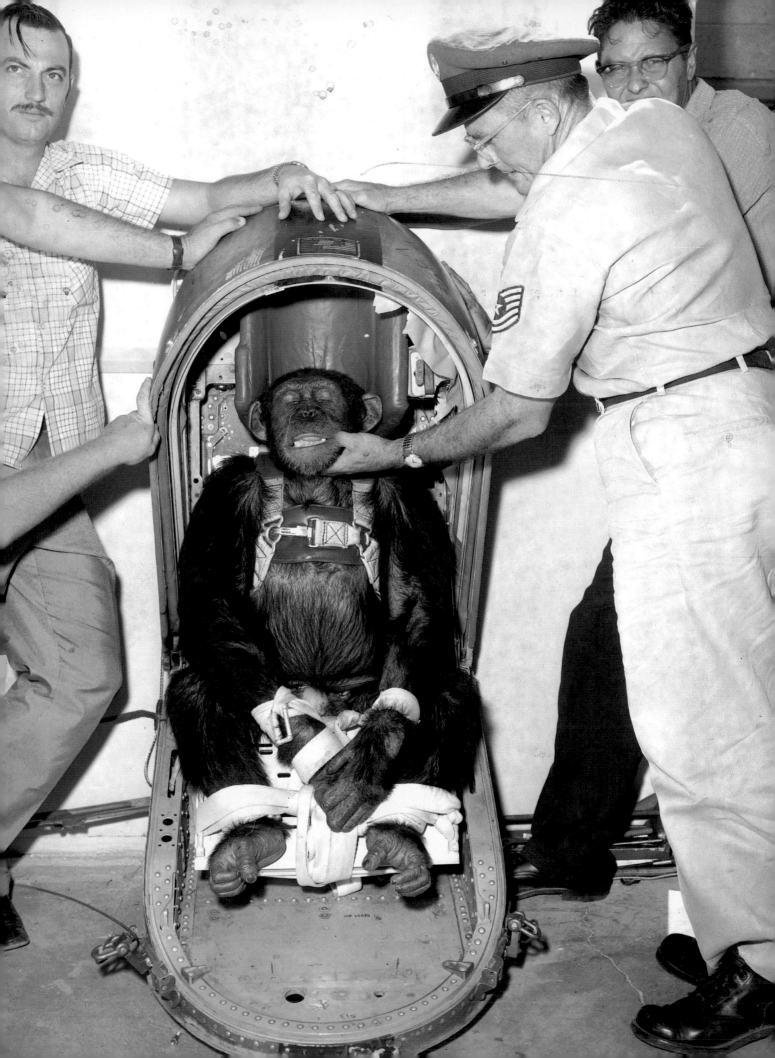

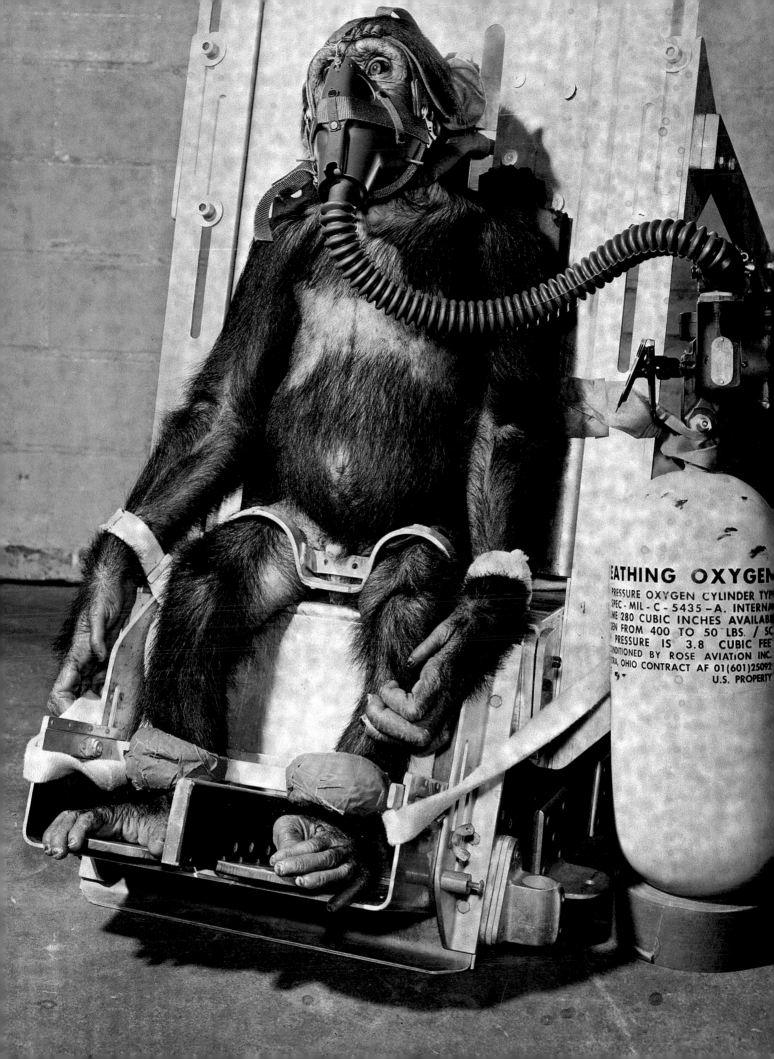

BREATHING OXYGEN

PRESSURE OXYGEN CYLINDER TYP
SPEC - MIL - C - 5435 - A. INTERNA
ME 280 CUBIC INCHES AVAILABL
EN FROM 400 TO 50 LBS. / SC
PRESSURE IS 3.8 CUBIC FEE
NDITIONED BY ROSE AVIATION INC.
RA, OHIO CONTRACT AF 01(601)25092
U.S. PROPERTY

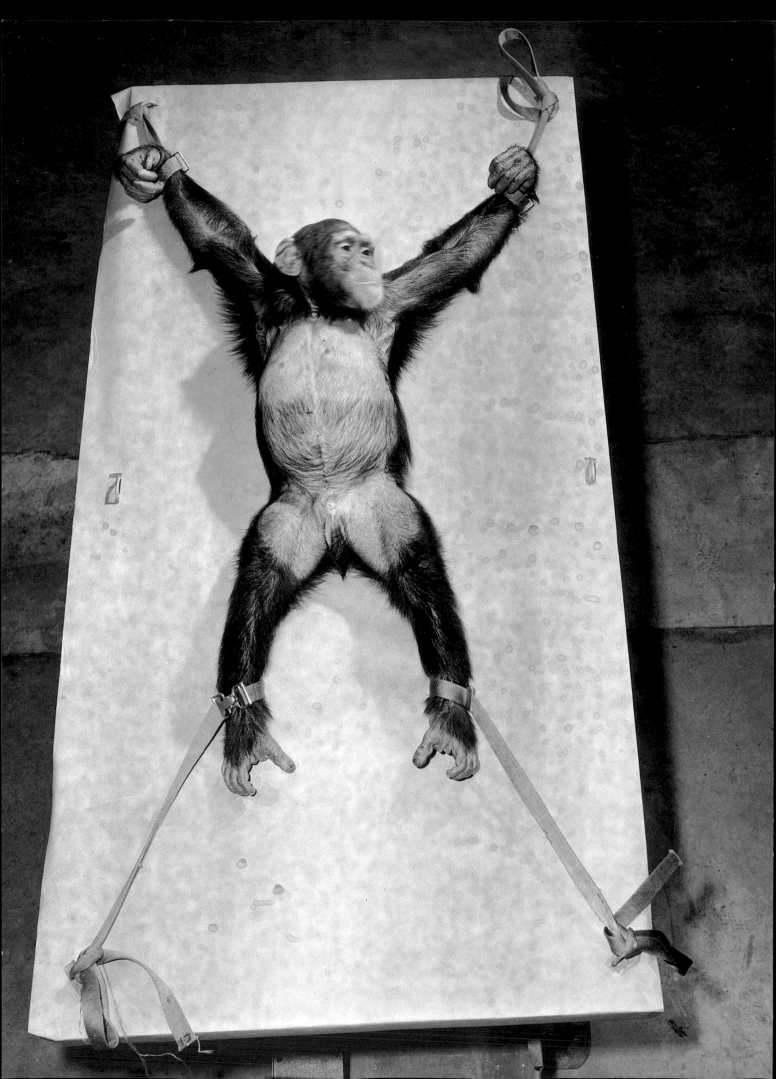

with my own eyes. He was lying on his side, tied by his waist to the top of a tiny wire cage. I went over and crouched down to speak with him. It was very hot under the sparse zippers of shade cast by the ragged leaves of an acacia tree, and the infant was damp with sweat, his eyes glazed. He looked close to death. Yet when I made the tiny panting sound of a chimpanzee greeting, he sat up and reached to touch my face.

What a dilemma: buy such a sad little orphan and you may encourage the capture and sale of live animals. Almost certainly the infant was a by-product of the bush-meat trade, the commercial sale of meat from animals shot in the forests; there is so little flesh on an infant chimp that the hunter will often try to get a little cash by attempting to sell the infant as a pet. But it also happens that the hope of a sale will cause the hunter to shoot a mother deliberately in order to steal and sell her infant. Obviously, we could not buy this baby, yet how could we abandon him?

That evening we drove past the market again. It was dark, and the stalls were closed, but the little chimp was still there, tied onto and curled up alone his cage. The car paused and I called to him through the open window; he sat up, a tiny forlorn figure, and reached out toward us as we drove away. Late into the night Nick and I agonized over what we should do. Sleep was impossible. Fortunately most African countries have a law prohibiting the hunting and sale of endangered species without a license, and chimpanzees are listed as endangered. This law is seldom enforced, but the next morning the minister of the environment agreed to confiscate our little chimpanzee. And so we were able to return to the market with a gendarme, the American ambassador, the minister, and Graziella Cotman, a local expatriate who had offered to try to nurse the infant back to health. Little Jay, as we called him, was officially confiscated and handed over to Graziella.

That was the beginning of JGI's first sanctuary for orphaned chimpanzees. Other confiscations followed and Graziella's family grew. Eventually the petroleum company Conoco, which was exploring for oil nearby in the Pointe Noire region, offered to build us what is now our Congo Republic sanctuary, offering refuge to JGI's biggest group of orphaned chimps (other, smaller sanctuaries are located in Kenya, Uganda, Tanzania, and South Africa). And even when Conoco pulled out of their explorations (their concession yielded no commercially viable oil), they left a team behind to honor their commitment. I was there last week (February 1998); the sanctuary now houses a total of sixty-three chimpanzees, in four separate groups, and Jay is one of the two magnificent young males now competing for the dominant position in the original group.

All the rescued chimps are special, but one is most special of all: Gregoire. When I met him, in 1988, he lived in a cage, dark and bare, in the Brazzaville zoo. He had almost no hair and every bone in his body showed under his skin. In the evenings and at weekends, Congolese children sometimes came to gaze at him or to tease him. The sign over his "home" informed me he had been born in 1944—when I was ten years old, dreaming of

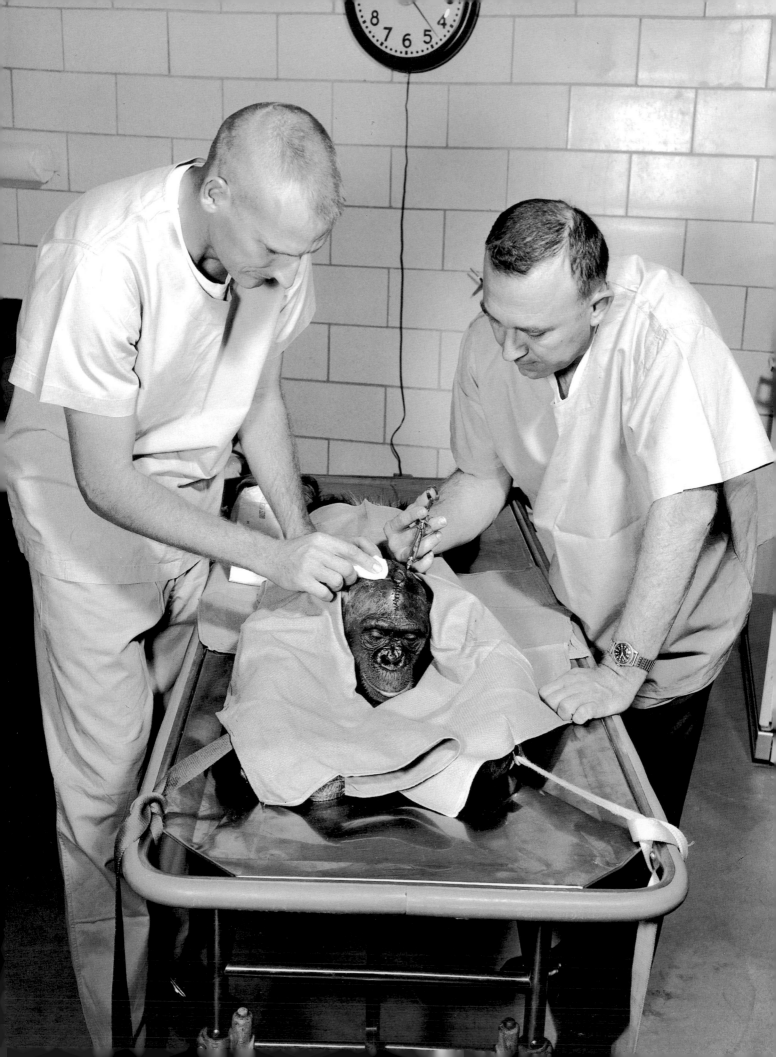

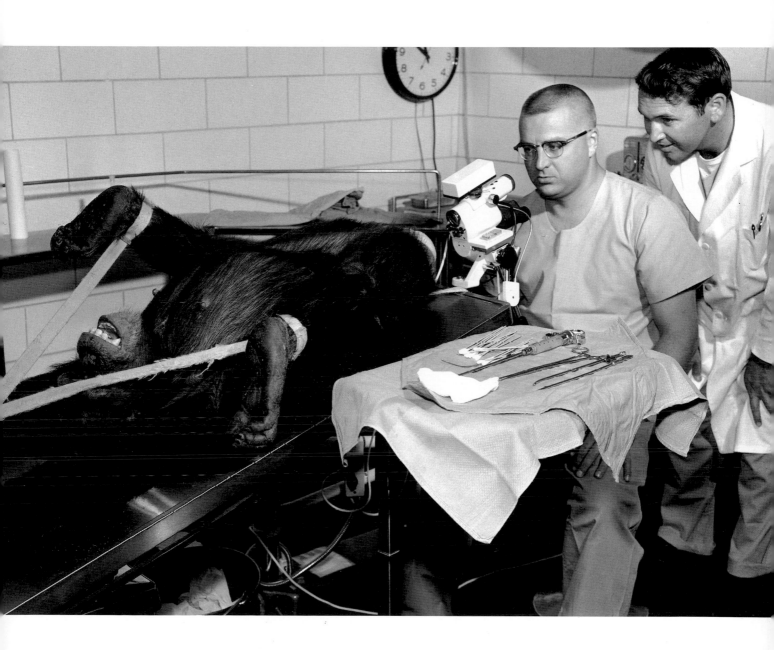

Tarzan in the jungles of Africa. So starving, so alone; how had he survived? I encouraged a group of expats to save food for him, we hired a couple of keepers, and Gregoire (and the other primates) put on weight. The film star Brigitte Bardot saw footage of the old chimpanzee and sent money to build him a patio so that he could feel the sun. Graziella introduced him to a four-year-old orphan chimpanzee, Bob, and then to a three-year-old female, whom Gregoire loved as a granddaughter. I called her Cherie.

It is 800 miles from Brazzaville (also in the Republic of Congo) to Pointe Noire. In 1997 fighting broke out again in the Republic of Congo between the two main opposing factions in the country. The Brazzaville zoo, just a few hundred yards from the airport, was the center of the war zone. Fortunately a helicopter, lent by the French army to move a group of orphan gorillas, also rescued Gregoire and his young companions.

When he arrived at our sanctuary he was in a desperately nervous state, and his back was raw; every time there had been shelling, he had dived under his bench, scraping his skin. But now he is with the others, and he has started to play like a kid, this old gentleman who is at least fifty-four years old. I was with him last week.

Sometimes Gregoire interacts with La Vielle, one of the adult chimpanzees who was rescued from the "zoo" at Pointe Noire. Ever since I have known her, La Vielle has refused to leave her cage, refused to step off the concrete. At the zoo, she lived for three years with the door of her cage swinging free; she could have left whenever she chose. Even today, in the sanctuary, she will not join the others when they play in their huge enclosure. What horrible trauma took place, we wonder, that she could be so afraid?

Sadly, an endless succession of pathetic infants continues to arrive at our sanctuary. This is largely the fault of the logging companies, which are building roads into the last remaining rain forests in Central Africa, opening them up to settlement and to hunters. For hundreds of years, people have lived in harmony with nature, killing just those animals they needed to survive. Now the hunters kill everything they see and send the bodies out on the logging trucks into the towns to cater to the popular taste for the flesh of wild animals. This is the infamous "bush-meat trade," and it is sounding the death knell for thousands of animals of all kinds, including chimpanzees, gorillas, bonobos, and other endangered species. It also threatens the indigenous forest people, for when the logging companies move on, they leave behind a forest where only the smallest creatures remain. And we are guilty, for the timber trade in Africa exists to supply sections of the developed world with tropical hardwoods. We should buy wood only from responsibly, sustainably logged forests, where endangered animal species are protected.

Some chimpanzees fall into the hands of dealers in live animals. These men are the real villains, sending hunters out to shoot mothers deliberately and steal their infants.

Those that survive are exported, often illegally. Some of them end up in the entertainment business. With kindness, patience, and reward, a chimpanzee can be taught to do

almost anything. But to get instant obedience, which is required if a chimp actor is to deliver the same performance day after day, the trainer usually tries to establish him- or herself as an all-powerful, utterly dominant figure. This is done in "pretraining" sessions, when no one is around. Typically the young chimp is bullied into abject submission, usually by being beaten over the head with an iron bar. A number of circus performers have testified about this, thereby forfeiting their jobs. Just this week, in the UK, I was shown a secretly filmed video in which Mary Chipperfield, a member of the famous circus family, is seen forcing a terrified infant chimpanzee into a box, yelling at and seeming to beat him. She is being prosecuted for cruelty to animals.

Fortunately, more and more people are beginning to understand the cruelty that underlies the polished performances of chimpanzees—and of lions, tigers, bears, and other wild animals—in the circus, in advertising, in almost any form of entertainment. It is not uncommon today for people and especially children to boycott circuses using exotic animals.

But what of those chimpanzees that end up in medical-research laboratories, some 2,000 chimps imprisoned in labs worldwide—about 1,500 of them in the United States?

For Nick and for me, visiting the labs and looking into the bewildered, or sad, or angry eyes of the prisoners in their cages, is the worst kind of nightmare. Animal researchers, to make it easier for them to do what they feel they must do, often ignore or even deny the psychological needs of their subjects—which are so like ours. The trouble is that many lab chimps have learned to distrust and even hate humans; they await the opportunity to spit, to throw feces, to bite. We cannot blame them. But it means that those who work in the labs cannot imagine the dignity, the magnificence, of free-living chimpanzees. So how do we open blinded eyes, bring feeling to frozen hearts? Perhaps with stories; stories about the chimpanzees in the wild, the fascination of their lives in the forest.

If we succeed, if scientists start to see into the souls of the animals for whose plight they are to some extent responsible, they can no longer be at peace. For once we accept or even suspect that humans are not the only beings with personalities, not the only beings capable of rational thought and problem-solving, not the only beings to experience joy and sadness and despair, and above all not the only beings to know mental as well as physical suffering, we become less arrogant, a little less sure that we have the inalienable right to make use of other life forms in any way we please so long as there is a possible benefit for us. We humans are, of course, unique, but we are not so different from the rest of the animal kingdom as we used to suppose: the line between humans and other animals, once perceived as sharp, is blurred. And this leads to a new humility, a new respect.

How should we relate to beings who look into mirrors and see themselves as individuals, who mourn companions and may die of grief, who have a consciousness of "self"? Don't they deserve to be treated with the same sort of consideration we accord to other highly sensitive, conscious beings—ourselves? For ethical reasons, we no longer perform

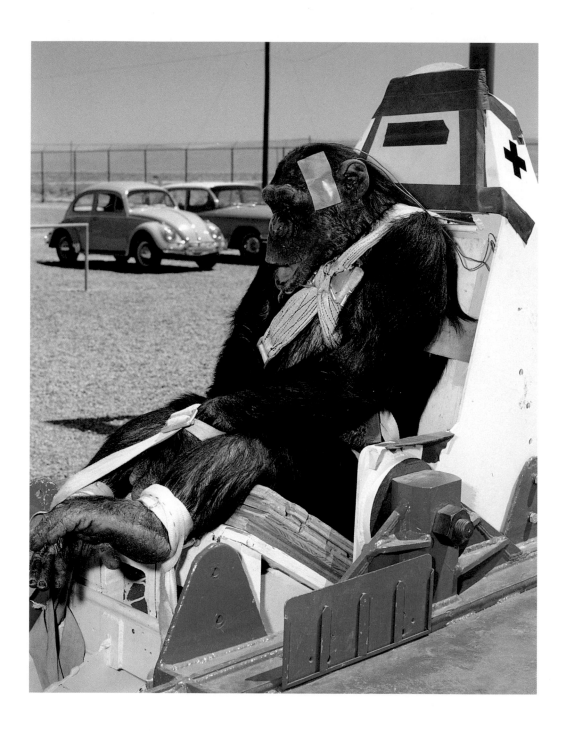

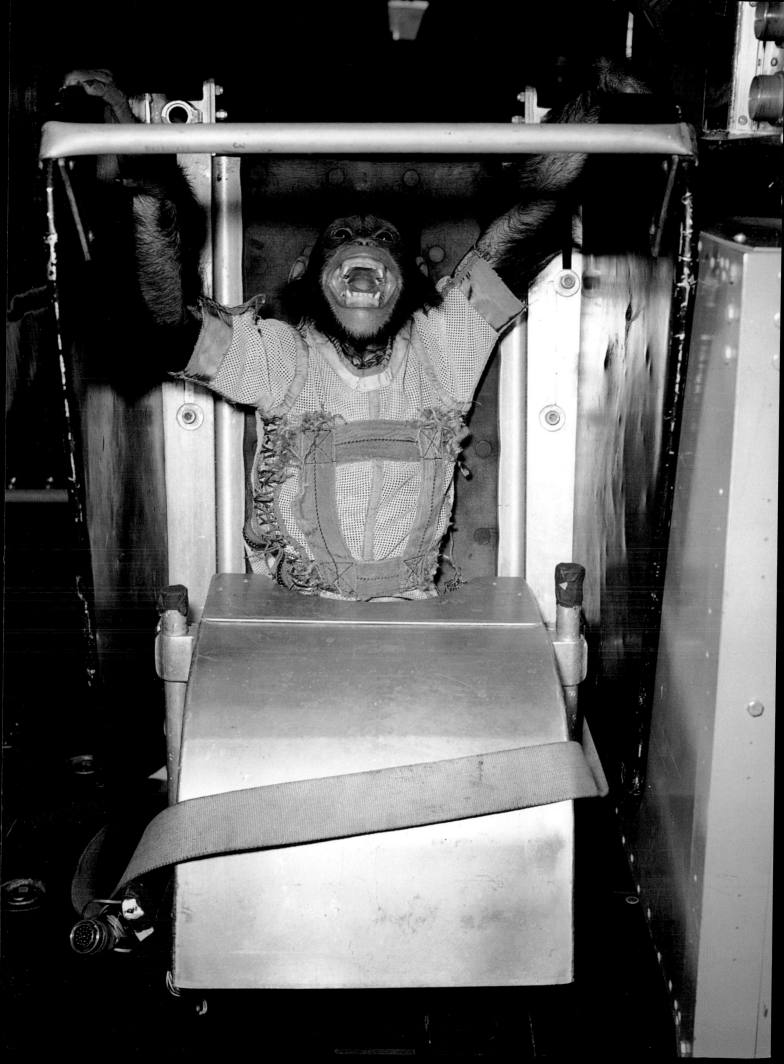

certain experiments on humans; I suggest that it would only be logical to refrain from doing those experiments on chimpanzees too.

JoJo was the first adult male I met when I visited the chimp colony at LEMSIP (the Laboratory for Experimental Medicine and Surgery in Primates, located at New York University). "He's gentle," said the veterinarian, Jim Mahoney, "he won't hurt you." I knelt and reached through the thick steel bars of his prison cell with my gloved hand. I thought of David Greybeard, the first wild chimpanzee to lose his fear and allow me into his world. JoJo had a similar face, and white hairs on his chin. As I looked into his eyes, I saw no anger, only puzzlement, and gratitude that I had stopped to speak with him, to break the terrible gray monotony of the day. And I felt deep shame, shame that we, with our more sophisticated intellect, with our greater capacity for understanding and compassion, had deprived JoJo of almost everything. Not for him the soft colors of the forest, the dim greens and browns entwined. Nor the peace of the afternoon when the sun flecks through the canopy and small creatures rustle and flit and creep among the leaves. Not for him the freedom to choose, each day, how he would spend his time, and where and with whom. Instead of nature's sounds of running water, of wind in the branches, of chimpanzee calls ringing through the forest, JoJo knew only the loud, horrible sounds of clanging bars and banging doors, and the deafening volume that chimpanzee calls build up in underground rooms. In the lab, the world was concrete and steel—no soft forest floor, no springy leafy branches for making beds at night. There were no windows, nothing to look at, nothing to play with. JoJo had been torn from his forest world as an infant, torn from his family and friends and, innocent of crime, locked into solitary confinement. No wonder I had a strong sense of guilt, the guilt of my species. Needing forgiveness, I looked into JoJo's clear eyes. And he reached out a large gentle finger and touched the tear that trickled down into my mask.

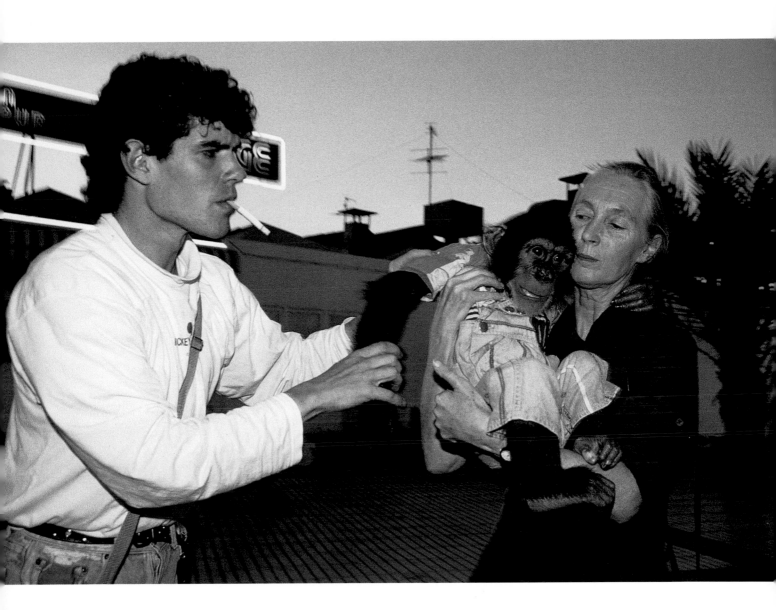

In the Canary Islands, Goodall helped to document the exploitation of young chimps used by beach photographers to earn tourist dollars. The lethargic chimps are clearly drugged. When Goodall made pant-grunts of greeting, the chimp she is holding here did not want to let her go. Thanks to the efforts of a British couple, Simon and Peggy Templar, and Jim Cronin of Monkey World in the U.K., this use of chimps in Spain has virtually ended. But it is springing up elsewhere.

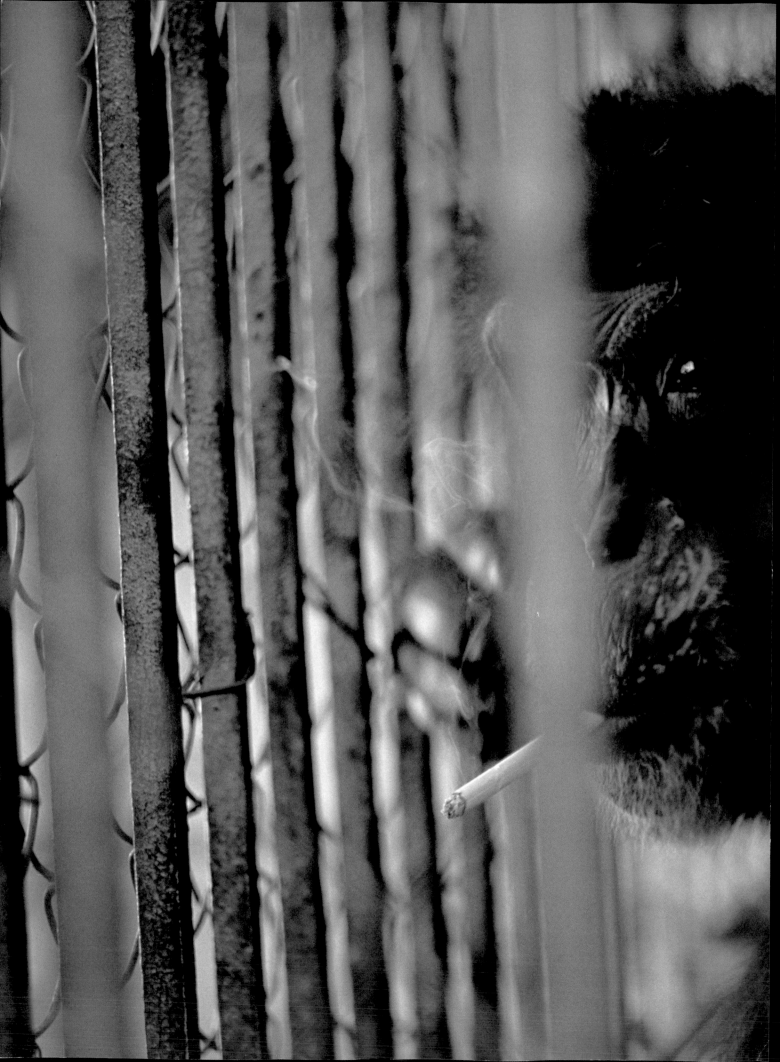

CHAPTER THREE RESEARCH AND CAPTIVITY

CHIMPANZEES ARE OUR CLOSEST RELATIVES IN THE animal kingdom. Certainly, this is one of the reasons why they are so fascinating as subjects for study, why they attract crowds in zoos, and why there has been such a market for them in the entertainment industry.

The fact that the genetic makeup of chimps differs so slightly from that of humans—by less than two percent—has also made these animals the prime subjects for experiments that no human wants to undergo. Chimps are currently used in research on AIDS, HIV, hepatitis, and other illnesses.

I entered the biomedical community under the auspices of Dr. Goodall, and therefore only came into contact only with laboratories that were sympathetic to her proposed changes, or that felt their compliance with U.S. Department of Agriculture regulations made it safe for them to be examined by journalists. In two years of documenting the topic of chimpanzees in medical research, only three labs allowed me to take photographs.

There is a lot of money behind the testing of chimpanzees. The bulk of that money is put to use for research and experimentation, while the budget for the care of the animals is secondary. Far more attention is given to clinical care as opposed to social care. In the labs where I photographed—which, again, represent probably the best-run and most humane animal-testing programs in the world—I saw chimps in heartbreaking conditions.

(continued on page 88)

Pages 76-77: Sam, a former carnival chimp abandoned by the show, now spends his years caged beside his owner's bar in Maineville, Ohio. In spite of posted signs, visitors still sneak cigarettes to him; he lights up for himself. Animal rights groups lobbied to have the owner prosecuted. While the case was pending, Sam was housed in a university facility. Although his owners won the case, they attempted to improve Sam's quarters when he was returned to their care. **Opposite**: A young chimp held captive in Monrovia. It was later learned that this chimp was killed and eaten during the Liberian Civil War. **Page 80 (top)**: A hunter in Liberia demonstrates the technique he uses to hunt chimpanzees. He sells the meat to miners in the nearby Nimba Range. If the target chimpanzee is a mother, her infant is sold alive, often to an animal exporter. **Bottom**: Longtime Sierra Leone citizen Franz Sitter is a notorious chimp trader who admits to having bought and exported many chimps in the past. It is estimated that ten chimps die for every one chimp successfully exported. **Page 81**: Africans and expatriates all over Africa's west coast often buy chimps from hunters as pets. Cute as helpless babies, in four to five years they become strong and dangerous. Sometimes they are killed. Or they are tied up in chains, confined in basements or in small cramped cages. **Page 82 (top)**: In Sierra Leone, a young man is at the beach trying to sell this young chimp, who is dehydrated and frightened. Generally, chimps are terrified of water. **Bottom**: The Monrovia Zoo in Liberia was founded and run by a local schoolteacher as an educational resource. The chimps on display there were obtained from people who had bought baby chimps from poachers, only to discover that they could not take care of them. The zoo was destroyed and the chimps eaten during the Liberian Civil War. **Page 83 (top)**: At the Monrovia Zoo. **Bottom**: In Tai Village, which is adjacent to Tai Forest, Côte d'Ivoire, this adult chimp is chained in place to endure the taunts and physical abuse of the villagers. The "village mascot" was named after an assassinated ex-president of bordering Liberia.

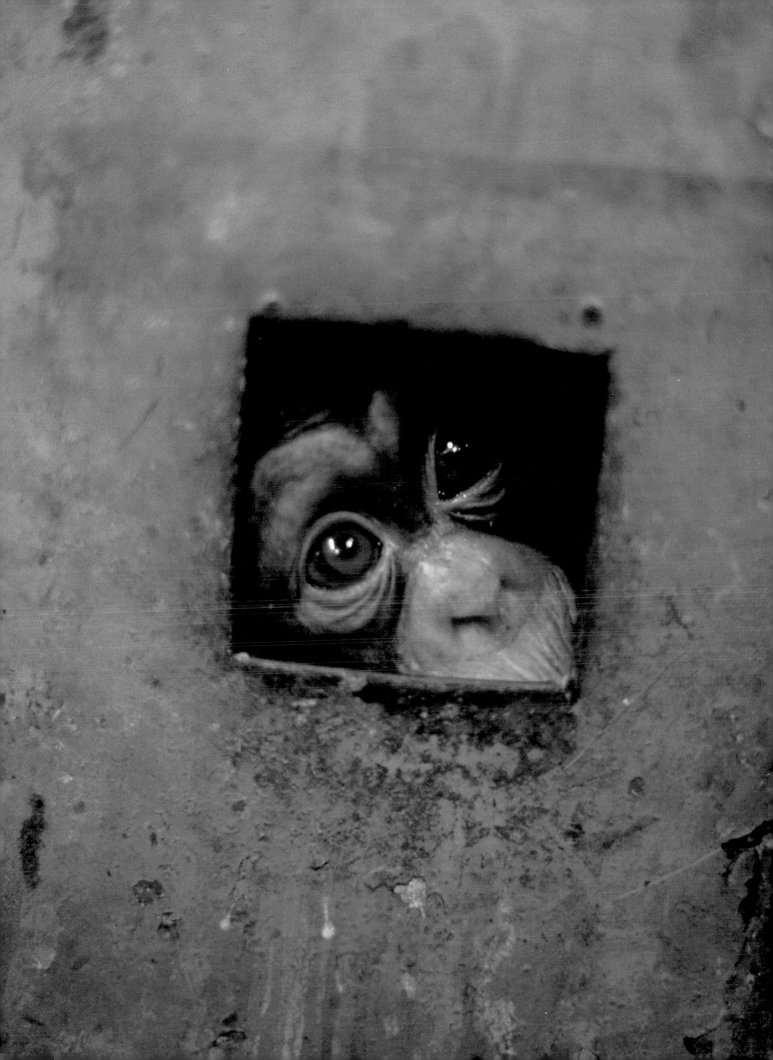

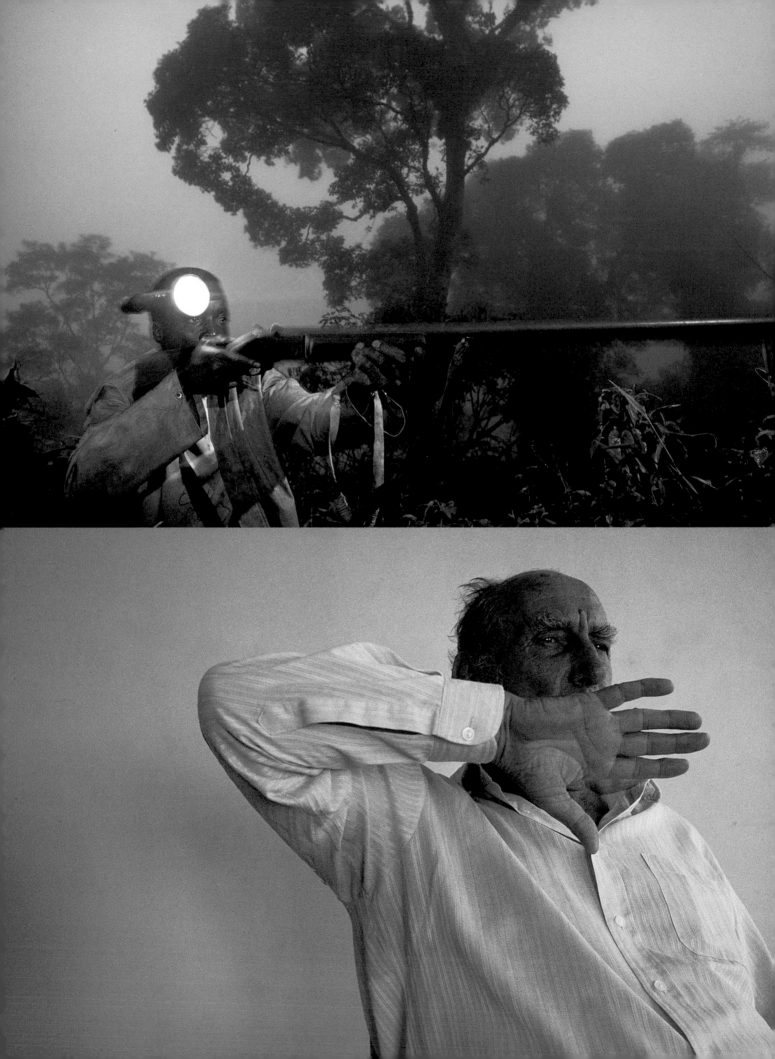

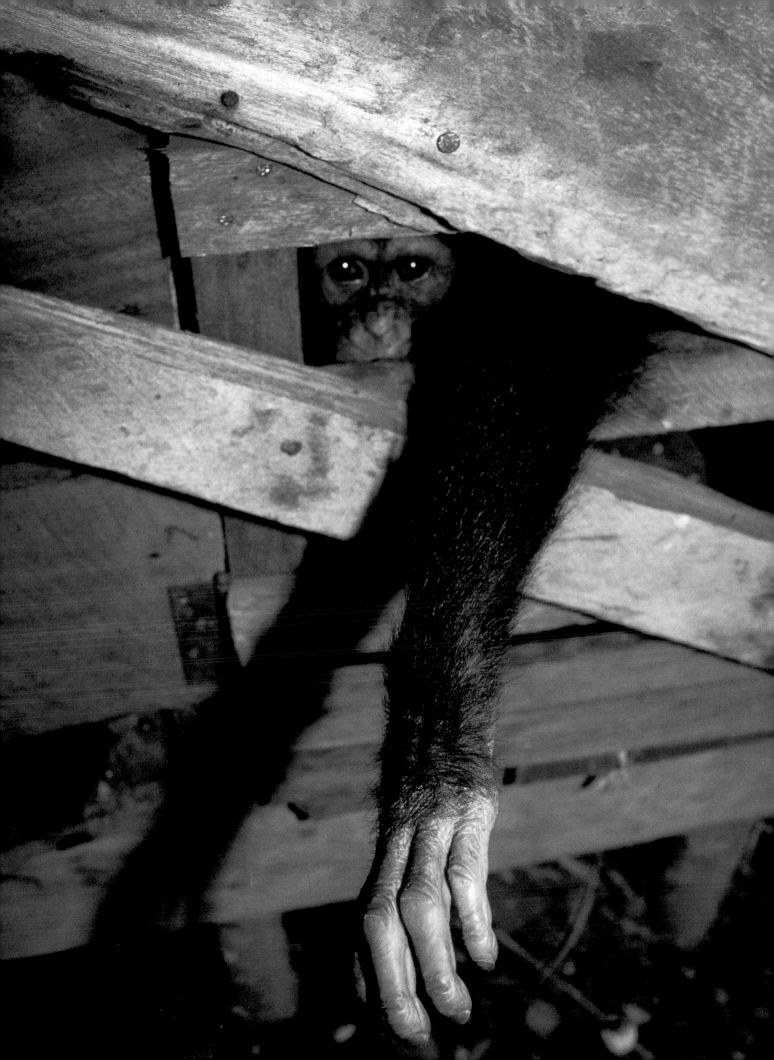

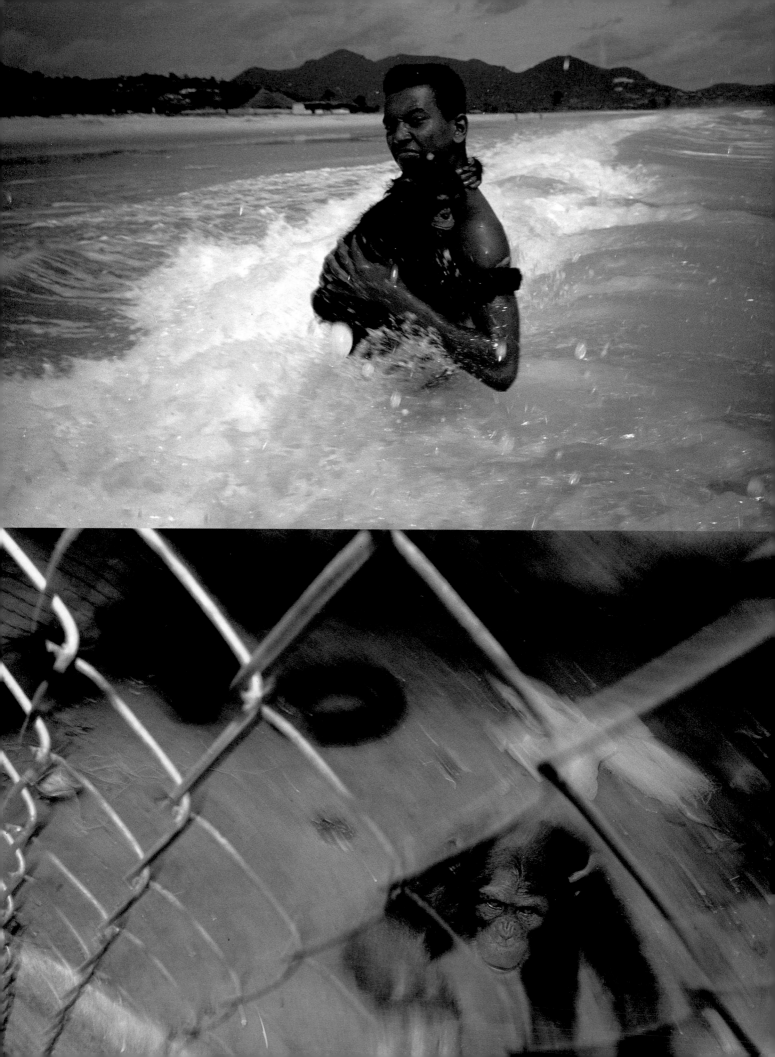

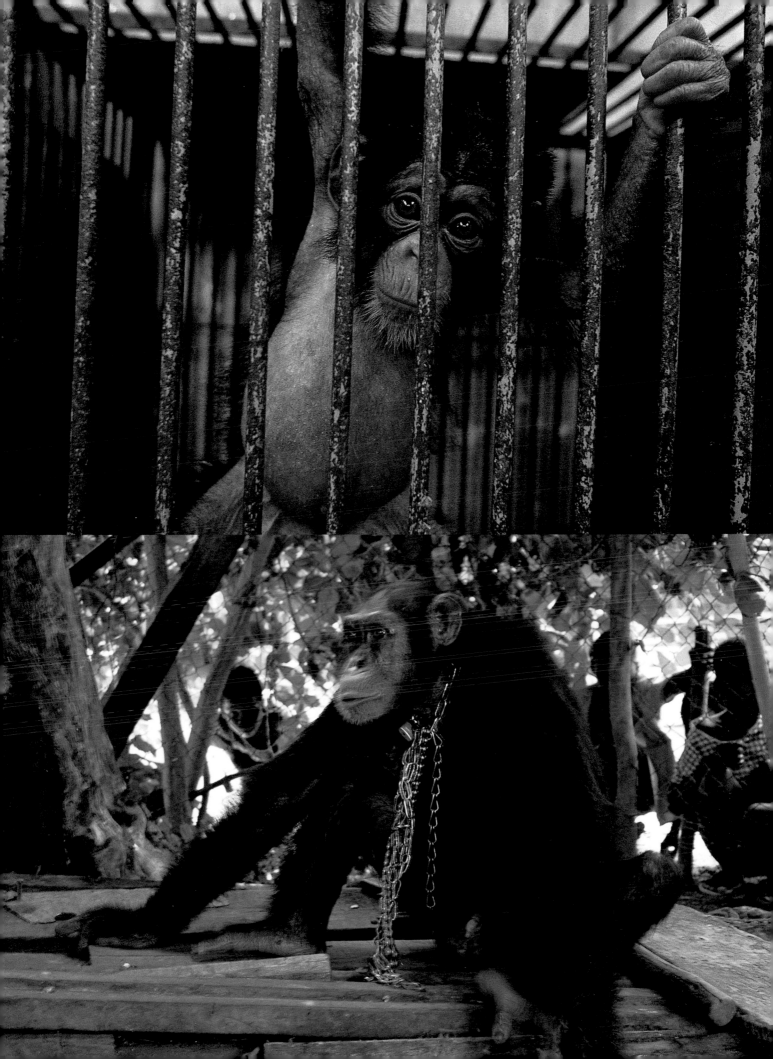

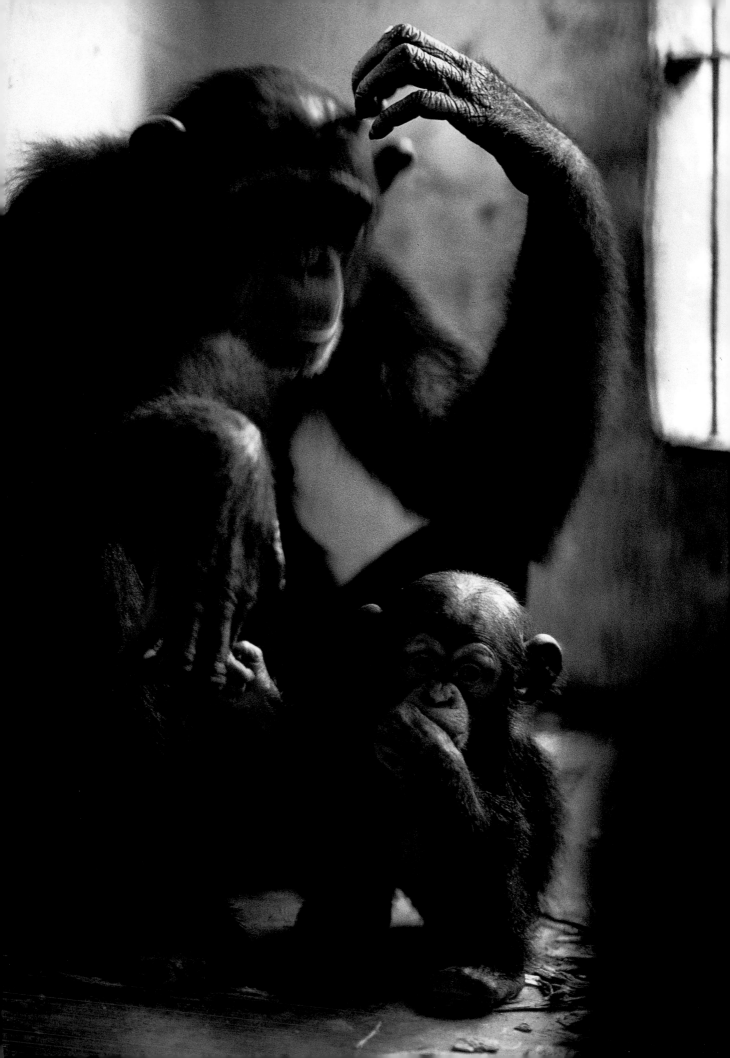

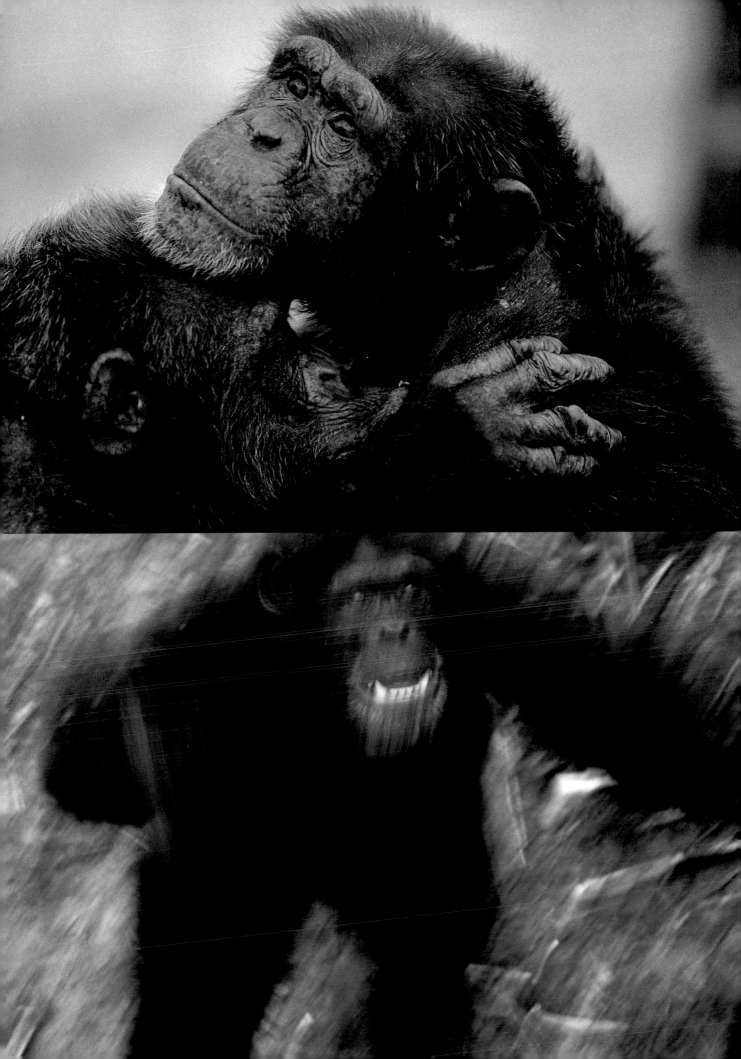

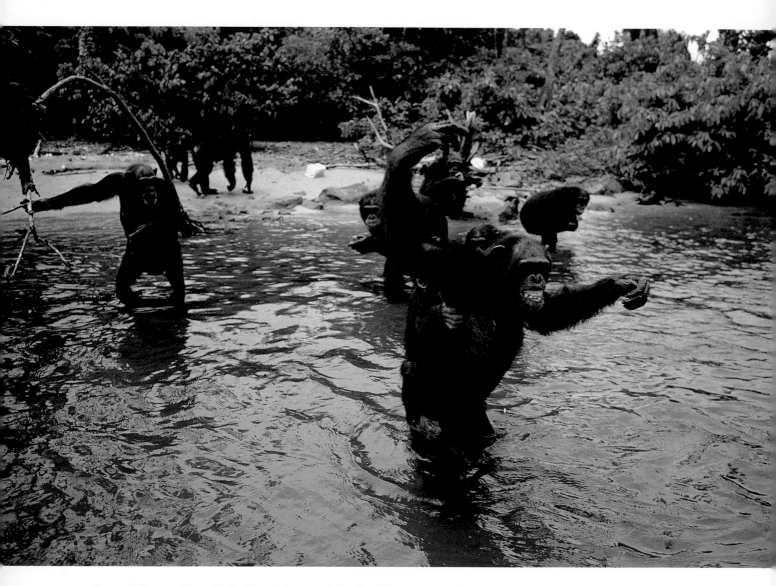

Page 84: VILAB New York Blood Center, Liberia, West Africa. A mother chimpanzee and her baby in one of VILAB's social holding areas. There is no hope for freedom for these animals; such chimps have never been successfully introduced to the wild. Wild chimps will attack and kill strangers. VILAB released infected chimps from hepatitis studies onto uninhabited islands where food had to be provided. *Page 85 (top)*: Chimps in captivity must be allowed to touch and groom one another. The VILAB chimps were used to develop hepatitis vaccines. *Bottom*: VILAB's male chimps constantly display anger at any sign of a visitor. Chimps in the wild display, as well, to improve or maintain their position in the hierarchy. *Above and opposite*: VILAB maintained three retirement islands for chimps that have been phased out of medical research. The islands, surrounded by brackish water, had insufficient natural food. As a result, the chimps were dissatisfied with their habitat and acted aggressively toward visitors. These chimps were killed during the Liberian Civil War.

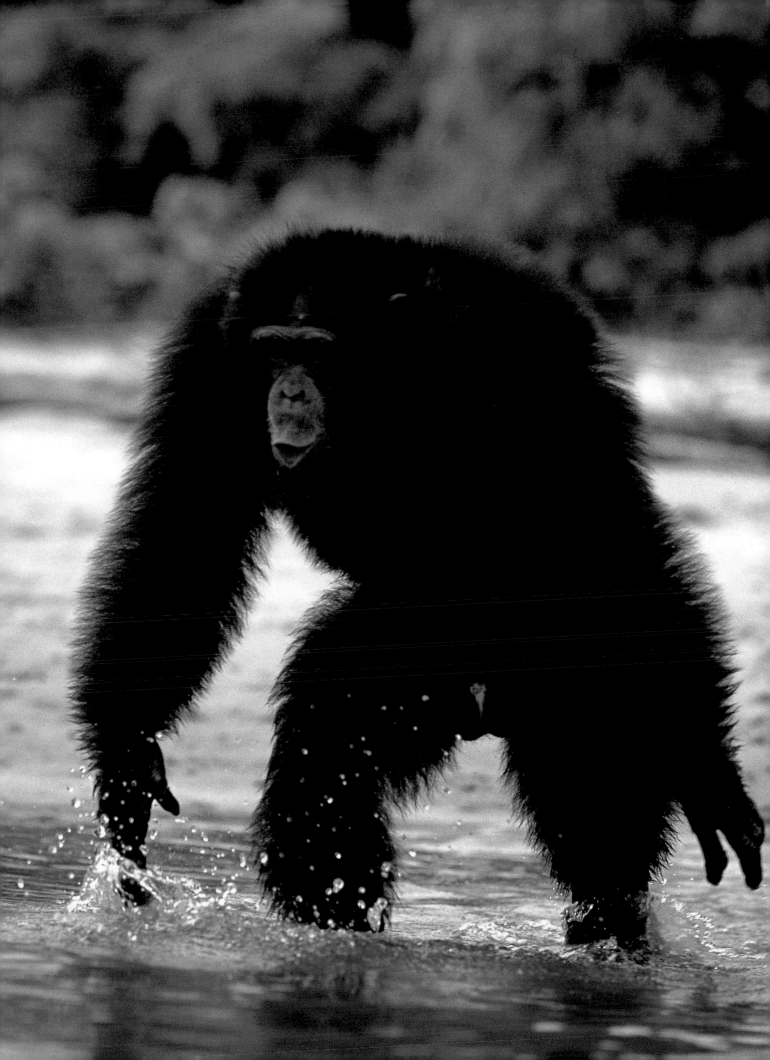

(continued from page 78)

At the Laboratory for Experimental Medicine and Surgery in Primates (LEMSIP) AIDS facility, which was in operation near New York City until 1997 and held around 250 chimps, former director Jan Moor-Jankowski designed a setup that was state of the art for chimp maintenance. Six cages lined opposing walls of a windowless building; the cages were elevated for easy cleaning. The chimps could see one another, but were too far apart to have any contact. There was no outdoor holding or exercise area.

The first time I was in that AIDS facility, it was horrifying; because a stranger had entered, the chimps screamed and spat and threw feces. It's a cinderblock room, so if they really got going, slamming the bars of the cages, they could create a deafening sound. These chimps did not want to be there, and they could be really nasty. The AIDS building was not a popular place.

Efforts at providing so-called enrichment for the animals' environment—for example, showing them television programs or giving them toys to play with—were inadequate. Chimps, like humans, need a lot of varied stimulation, and they lose interest in anything if it is repeated too often. The regular staff, though very efficient, limited their interactions with the chimps, knowing the emotional price to be paid for too much involvement.

The chief veterinarian at LEMSIP, Dr. James Mahoney, was in a difficult position: he knew that conditions were not good, but he felt that they were as good as he could make them given budgetary and other restrictions. Dr. Jorg Eichberg, Mahoney's counterpart at the Southwest Foundation for Biomedical Research, in San Antonio, Texas, has developed a much-publicized "retire-

ment plan" for the chimps in AIDS and hepatitis research. The retirement housing consists only of cinderblock housing surrounded by a small outdoor yard.

Most of the chimps in our zoos, in the space program, medical labs, and the pet and entertainment trade come from West Africa, Guinea, Sierra Leone, Liberia, and Côte d'Ivoire—countries where the human populations and their needs have reduced the rainforests to small patches with no corridors for migration. Bush-meat (meat from wild animals, supplied by hunters) is a popular source of protein in these countries, and only the most inaccessible and remote forests have not been over-hunted. The demand for live animals is now met by a few isolated "suppliers."

Franz Sitter is a notorious animal dealer in Sierra Leone, whom I visited with Jane Goodall's son, Hugo Van Lawick III (nicknamed Grub). Chimpanzee researcher turned conservationist Geza Teleki has records showing that Sitter and another dealer exported more than 1,500 wild chimps from Sierra Leone between 1973 and 1979. When we spoke with Sitter, he defended his trade, claiming that the country was still covered with chimps, they were not endangered, and that if he did not export them for the admirable purpose of AIDS research, they would, as he put it, "end up in some villager's pepper soup" anyway. He also claimed that he no longer kept, bought, or exported chimps—but as he was making that claim, we could hear the familiar cry of the chimpanzees nearby. "That's the wild chimps living in the hills around the farm. As I said," Sitter defended himself, "the country is full of them."

There are no wild chimpanzees anywhere near Sitter's farm.

(continued on page 108)

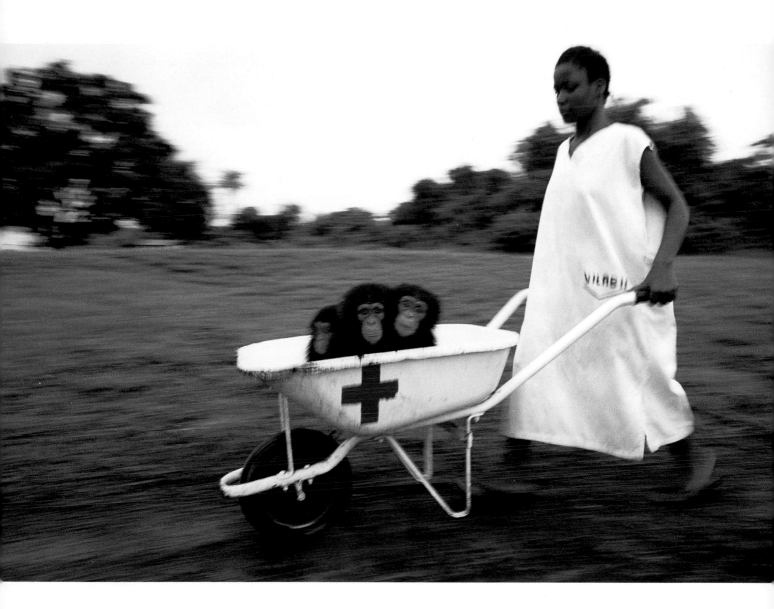

Three young chimps are transported by wheelbarrow at VILAB in Liberia, which was operated by the New York Blood Center. This lab was set up to facilitate the use of chimps. In Africa, it is cheaper to care for chimps and one can avoid problems arising from animal-protection acts, such as the CITES (Convention on International Trade in Endangered Species) Treaty, which make it illegal to remove chimps from Africa.

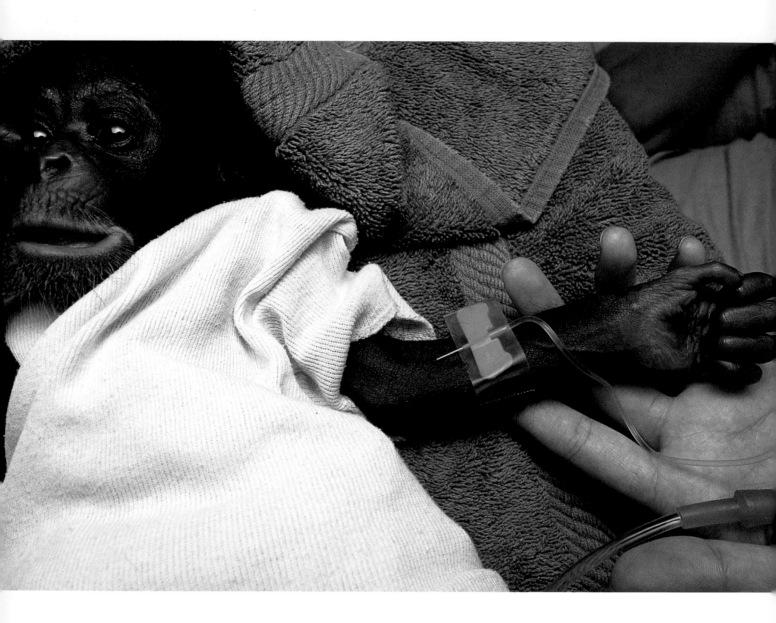

Above: A gravely ill orphan chimp clutches at foster comfort. His mother vanished after giving birth on a VILAB II retirement island; caretakers discovered the ailing baby with two males trying in vain to provide care. He died a few days after this photograph was made. Many of the mothers born in captivity lack care-giving skills.

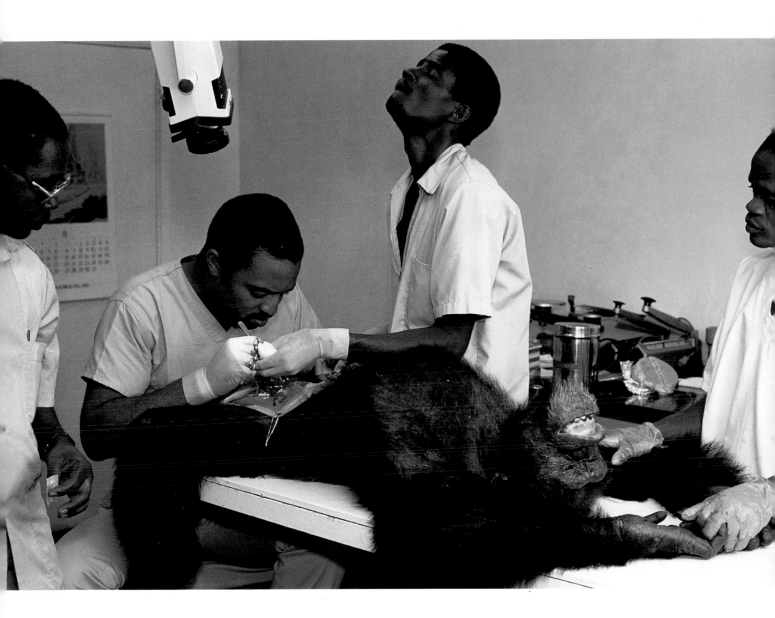

Above: A surgical team performs a sterilization at VILAB II to slow chimp breeding, which had produced an excess of animals. VILAB turned to birth control even as American researchers worried about shortages and the numbers of chimpanzees in the wild continued to decline.

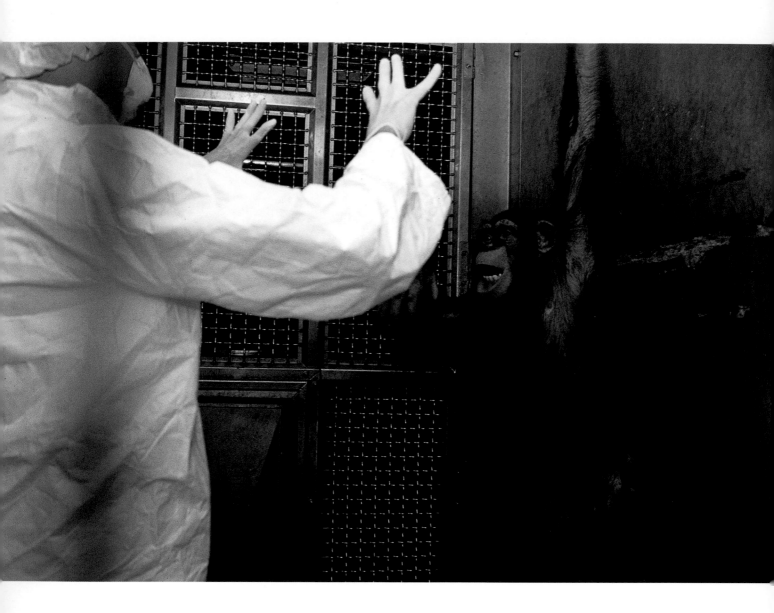

Above and opposite: A Southwest Institute technician in San Antonio, Texas, carries a chimp out of a cage area to be experimented on for a hepatitis study. *Page 94 (top)*: A Southwest lab technician taking the blood pressure of a chimp to be operated on for a hepatitis B study. B*ottom*: Veterinarian Rick Lee (left) removes a piece of the chimp's liver for this same study.

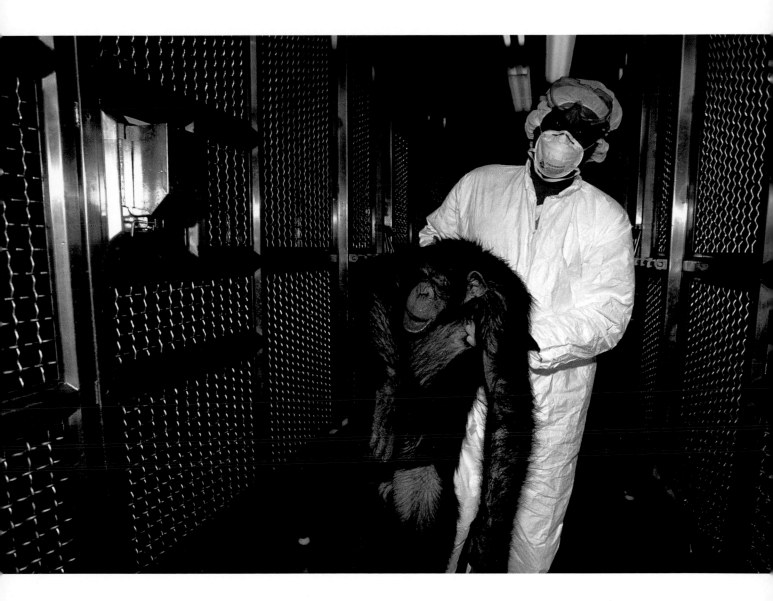

Page 95 (top): Dennis, a technician at LEMSIP (now closed) who cared for chimps with AIDS, gives some special attention to the animals in the form of Kool-Aid. Soap bubbles, balloons, tennis balls, combs, toothbrushes, jungle music, and TV are all given to the chimps to help relieve the boredom of confinement. *Bottom*: A Southwest technician feeds a one-week-old baby chimp. In research labs, captive mothers are often incapable of raising their infants. At Southwest, babies are hand-raised in a nursery. Only one person is allowed contact with the infants at Southwest, and the nursery is kept sterile. These babies are considered clean, non-infected animals and are very valuable for research.

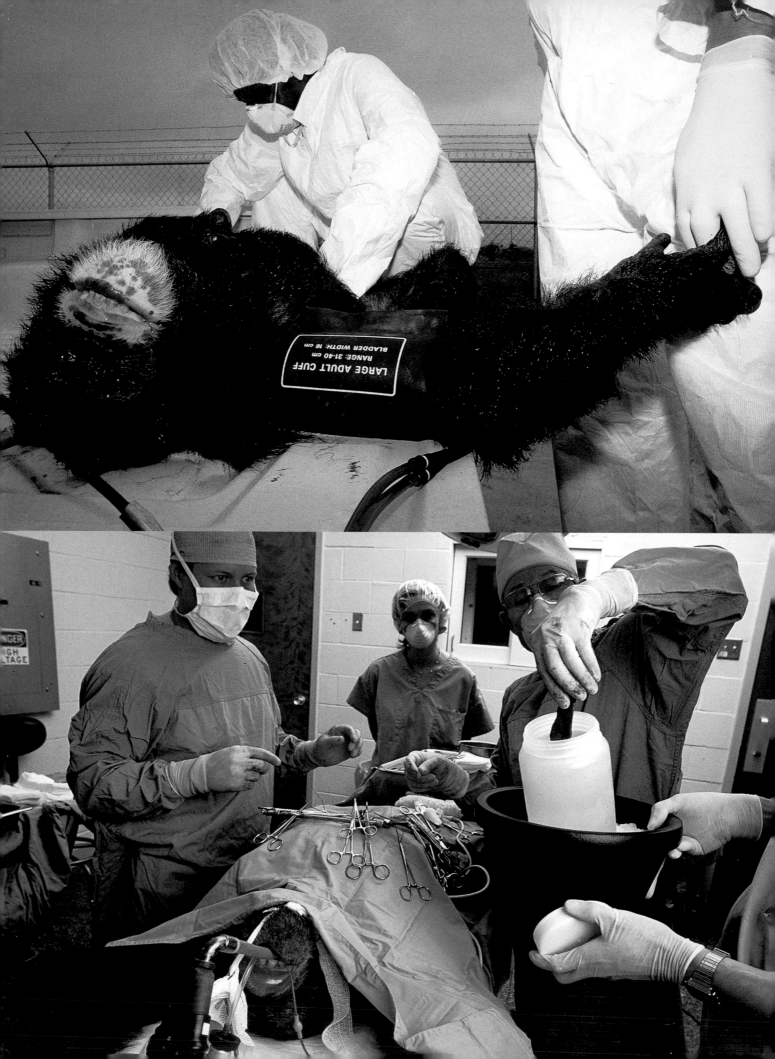

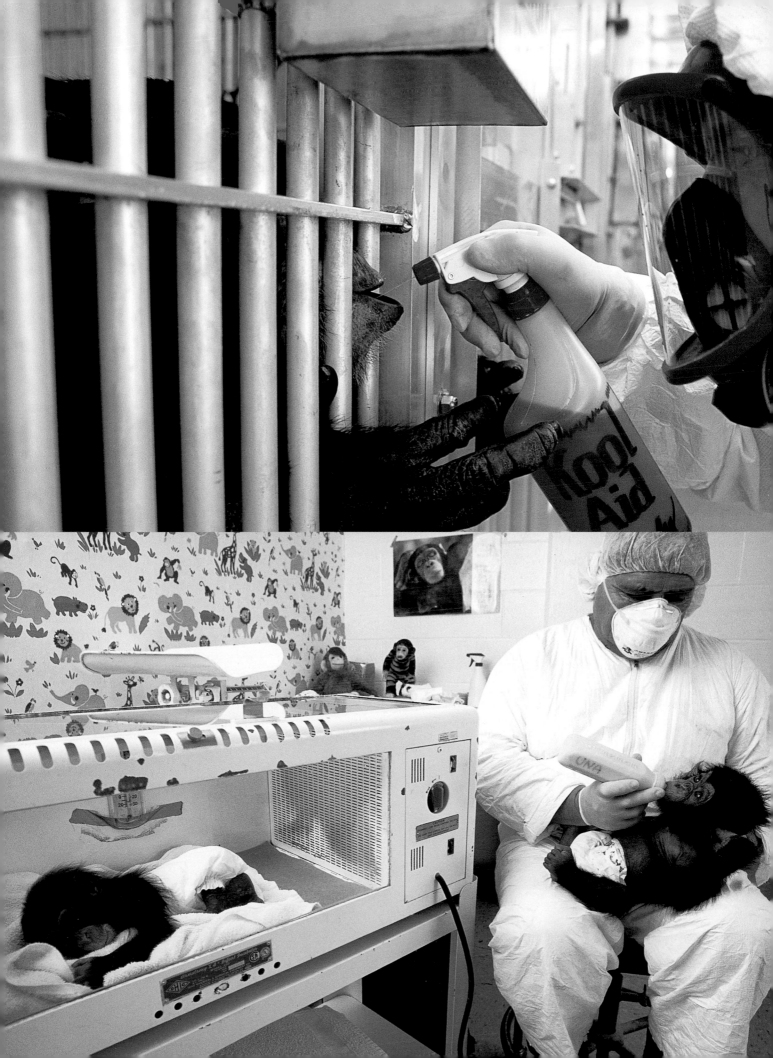

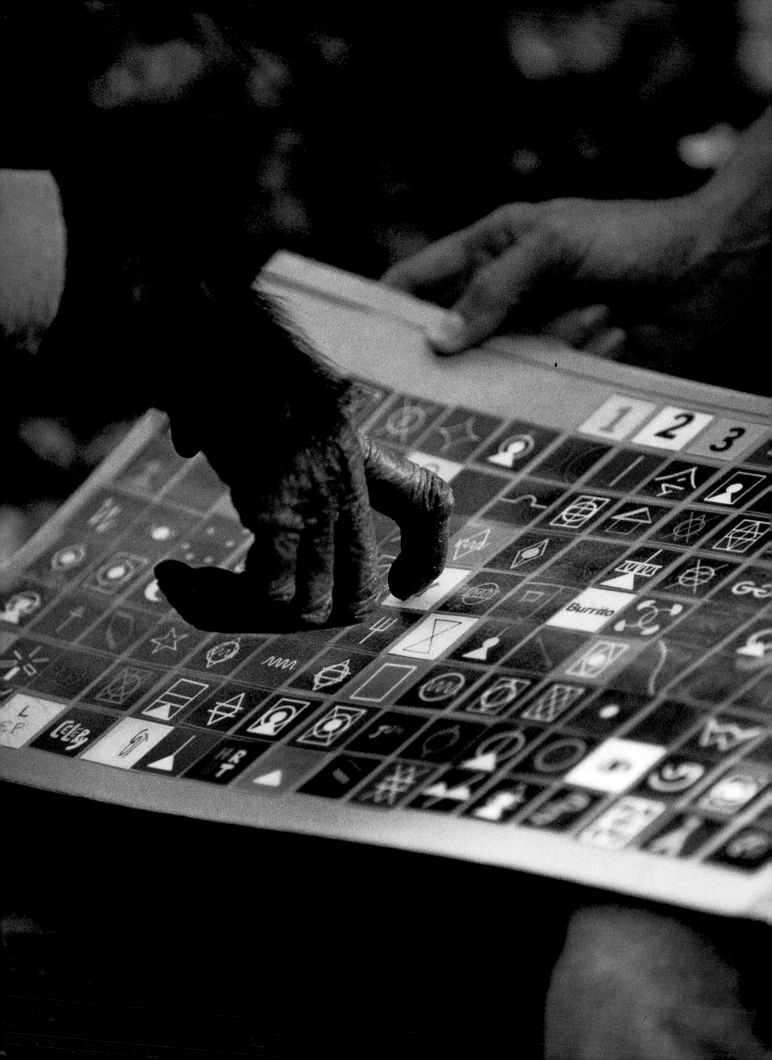

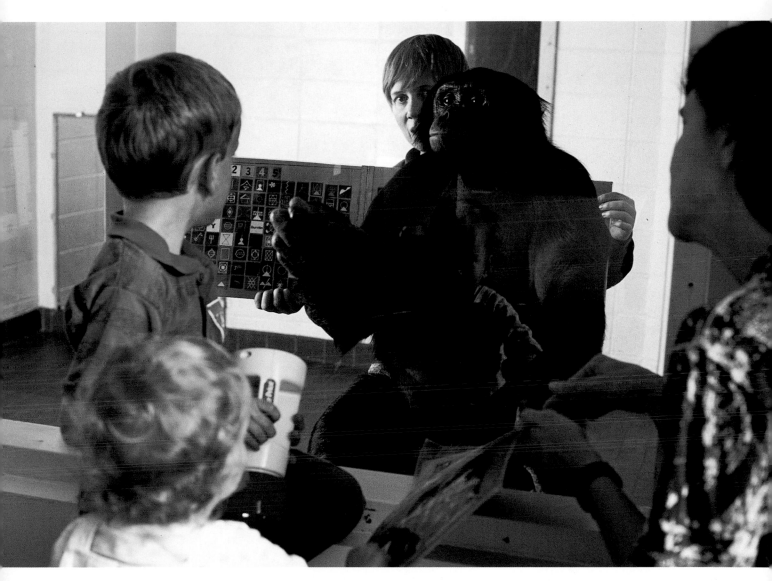

At the Georgia State University Language Research Center near Atlanta. *Opposite*: Before embarking on an afternoon walk, Panzee, a five-year-old chimpanzee, chooses one of the seventeen destinations that she is familiar with by touching the appropriate symbols on her keyboard. Here, chimps have also learned to count mathematically by operating a joystick that manipulates numbers on a video screen. *Above*: A bonobo called Kanzi says "Chase Kanzi" to a six-year-old boy, pointing to symbols on a keyboard held by researcher Sue Savage-Rumbaugh. The boy and his sister, regular visitors to the center, have also mastered the keyboard, which has recently been adopted for children and adults with autistic communicating disabilities. Savage-Rumbaugh has shown that chimps and bonobos can comprehend and use language spontaneously, as young children do, by listening and by relating the spoken words, the symbols, and the objects they represent.

A male chimpanzee in a breeding compound at Southwest Foundation for Biomedical Research. Female chimps are allowed to have eleven offspring. The first ten are taken for medical research. She is allowed to keep the last to raise herself. This last child lives in an enclosure with his mother that is larger than the ones for the other chimps, and will become breeding stock for the labs to ensure a steady supply of new test subjects.

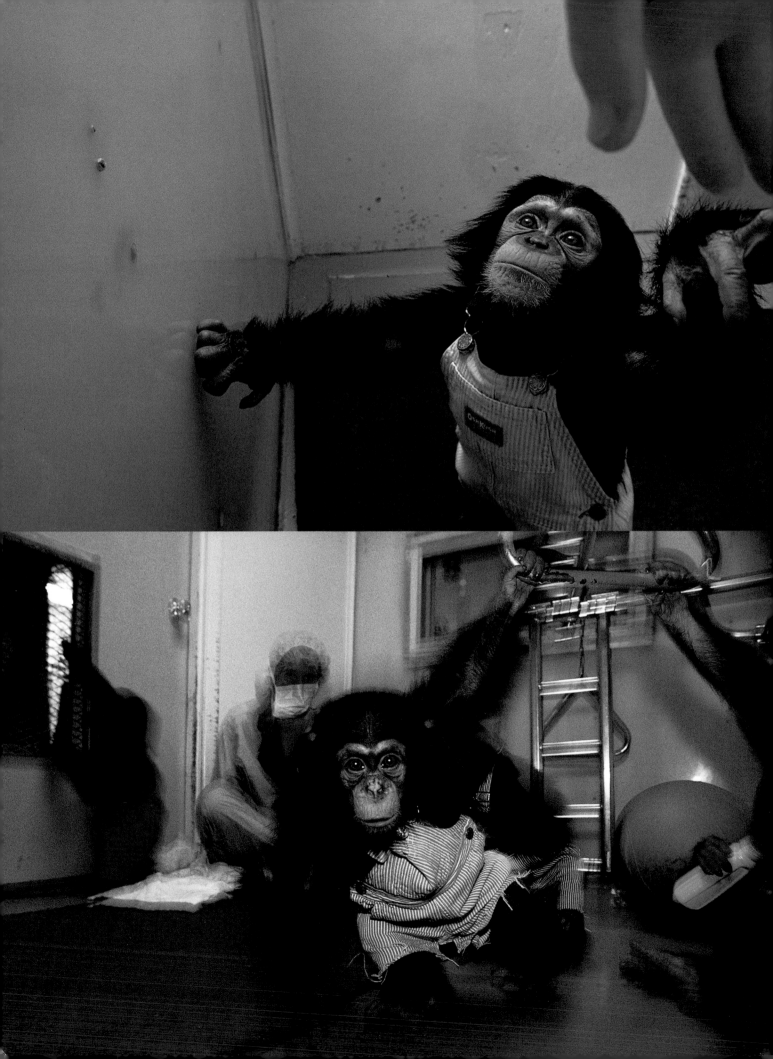

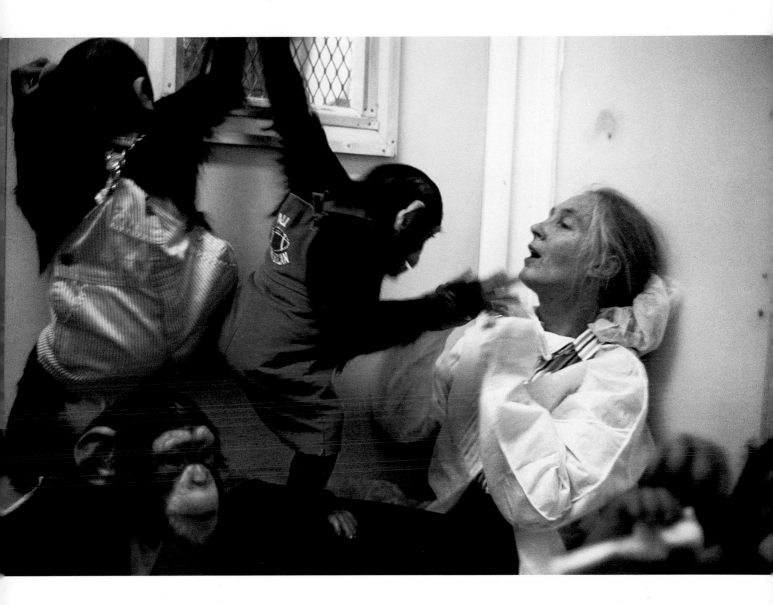

Opposite: LEMSIP's nursery was run very differently from Southwest's. Babies were dressed in human clothing, played with by volunteers, allowed to socialize with others, and basically pampered. The tragedy came at about one and a half to two years of age when the chimps were imprisoned in bleak cages, often isolated from physical contact with other chimps, and the medical research and experimentation began. ***Above***: Goodall visits LEMSIP to check out the living conditions of the chimps held there. The lab, of course, used the opportunity to improve its public image.

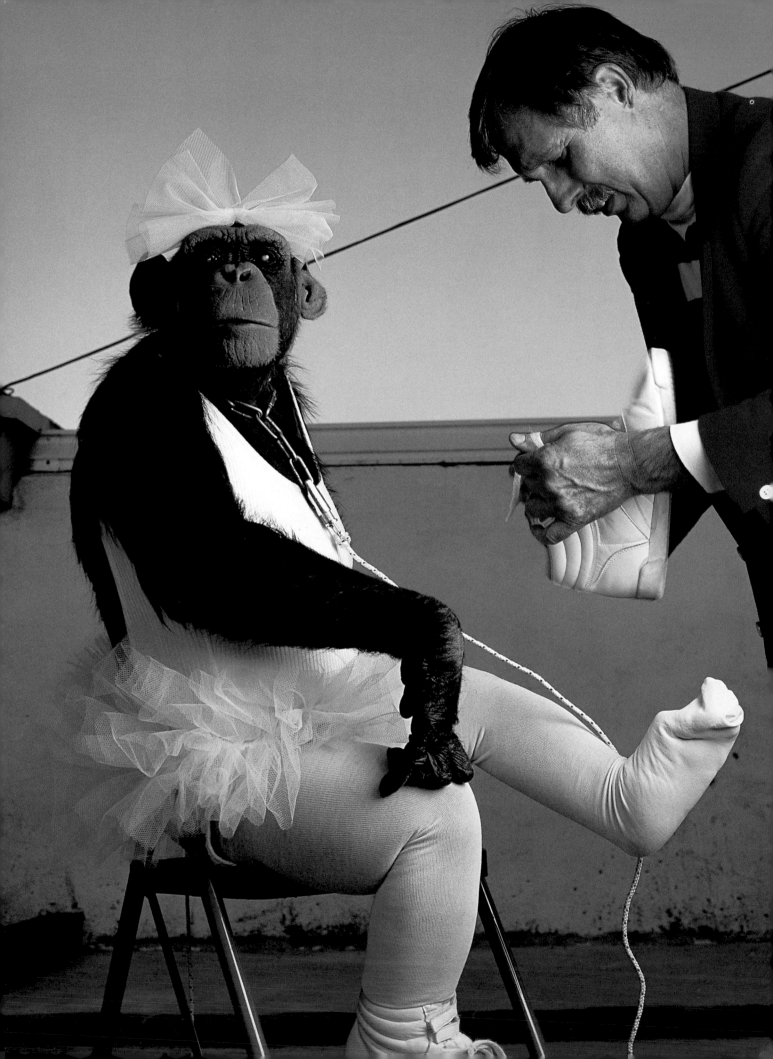

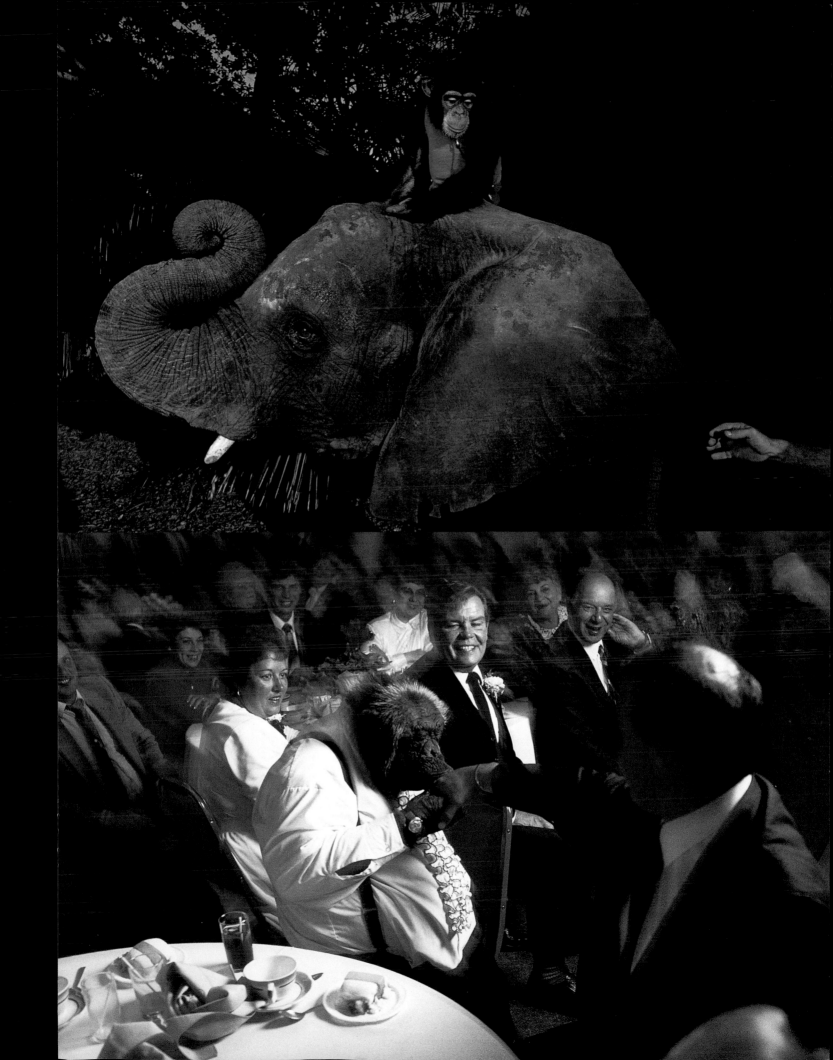

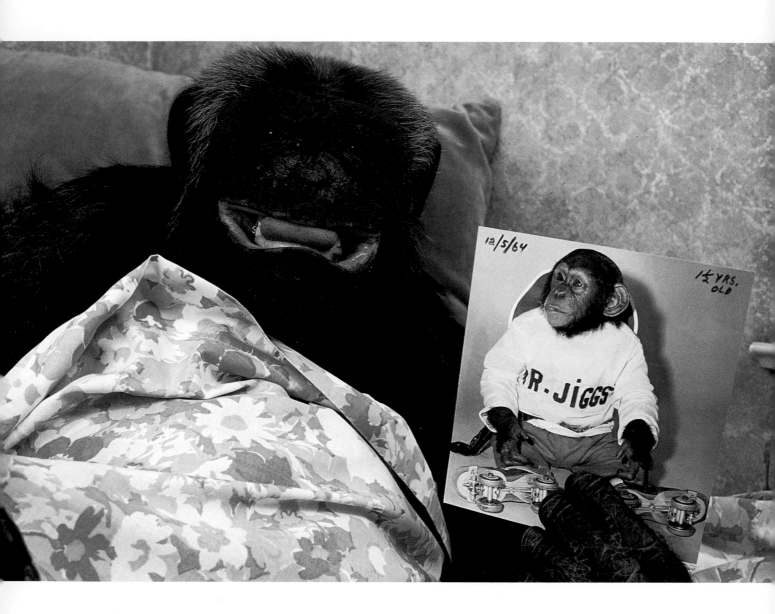

Page 102: At his home in Palm Springs, California, Dan Westfall kept forty-three-year-old chimpanzee Susie. As a member of the Marquis Chimps performing-animals act, Susie rode a unicycle to fame on the Ed Sullivan Show in the 1950s and 1960s. Westfall was one of the few trainers who did not use fear or intimidation with his chimps. Susie died last year of cancer in Westfall's arms. *Page 103 (top)*: Christopher, a three-year-old male chimpanzee, performs with a baby elephant at Jungle Larry's roadside attraction in Naples, Florida. His predecessors at Jungle Larry's were sold to research facilities. The cages for the chimps at Jungle Larry's are smaller than at LEMSIP or Southwest. Trainer John Illig uses stern commands and beatings with Christopher if he doesn't obey. If he were in the wild, Christopher would still be on his mother's breast. *Bottom*: A female chimp called Mr. Jiggs in the audience entertaining at a New Jersey Fireman's Ball. She was caught in the African wild, and her mother was killed during her capture.

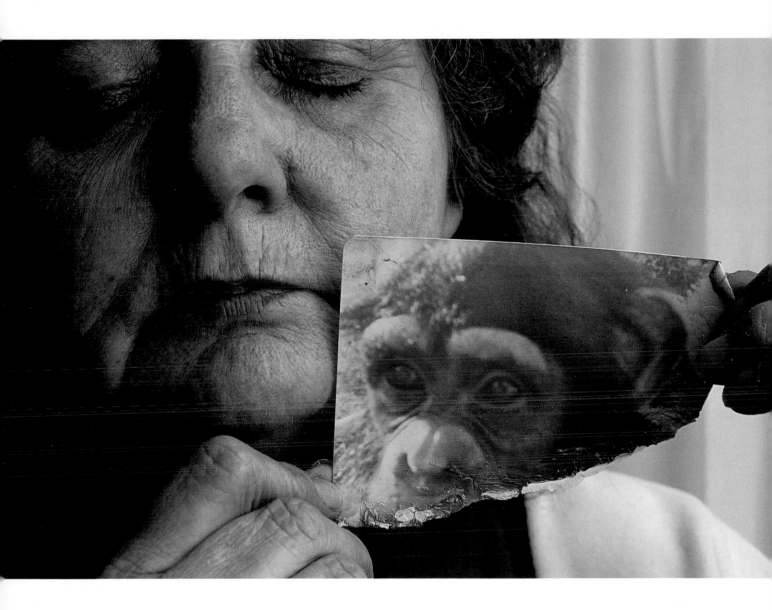

Opposite: Mr. Jiggs holds a photograph of herself made in 1964. She has been with her owner/trainer Ronny Winters for twenty-seven years. Winters invented the "radio-control unit," an electric-shock device, to control Jiggs. He also had all of Jiggs's front teeth pulled. *Above*: Roseanne D'Ercole, who owns a baby orangutan, has a fascination for apes and has filled her New Jersey home with live apes, ape dolls, and other ape memorabilia. Her baby orangutan alone probably cost $30,000. The photograph she holds is of her pet, Stella, who rescued the family from a burning house. *Page 106*: Tommy is a six-year-old male chimp raised by the wife of an American worker in Monrovia, Liberia. Tommy has been moved from the house to a wooden box in the yard since the couple found out they couldn't take him home when they leave Liberia.

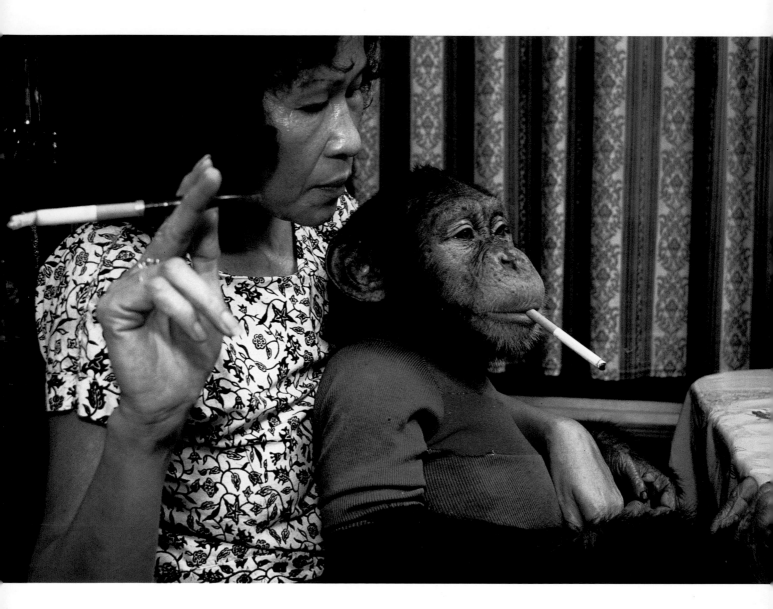

Opposite (top): Mae and Bob Noell own the Chimp Farm in Tarpon Springs, Florida, a roadside zoo and retirement home for performing chimps. The Noells were famous for a vaudeville act that traveled the Eastern Seaboard for thirty years. Dubbed "The Gorilla Show," the act featured a challenge to a local tough guy to a boxing match with an adult chimp. The Noells today are often criticized by the Humane Society and other animal-rights groups regarding the conditions of their cages. It is not known what will happen to the chimps when the Noells pass on. *Bottom*: In Clearwater, Florida, Gina Valbuena makes a living as a photographer. She often photographs her two chimpanzees and orangutan in funny poses. Gina raised Coby (seen here) and he identifies her as his mom. But he will soon be too big and strong to handle. Valbuena has previously sold her chimps to research labs when they got too big. For Coby, she contemplated buying a radio-controlled shock device from Ronny Winters.

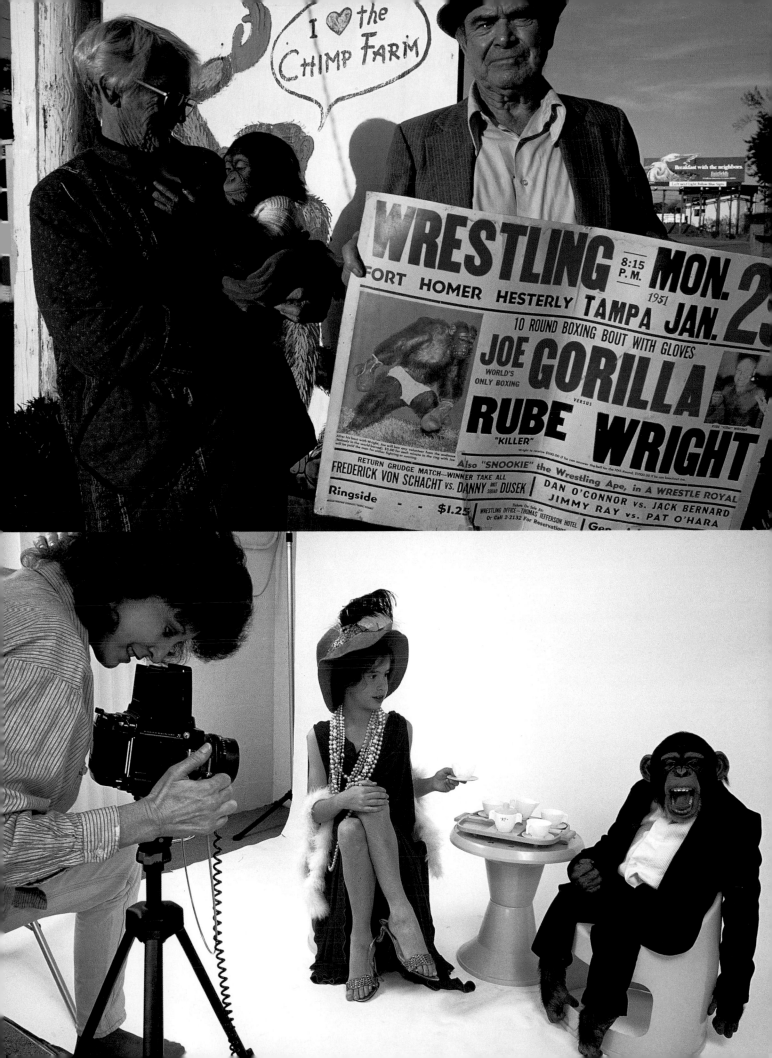

(continued from page 88)

There was a time when zoos were the main clients of animal exporters like Sitter. Today, zoological parks in the U.S. no longer import apes. Accredited zoos around the world are now unified by the goal of preserving the genetic diversity of endangered species. Zoos have evolved greatly since their beginnings in pure entertainment. The New York Zoological Society is planning a new enclosure for lowland gorillas, which will cost in excess of ten million dollars. But no matter what their expense, indoor ape exhibitions that try to appear naturalistic with ape groups that are not properly socialized fall short. If we want humans to see apes somewhat as they are in the wild, they must be allowed to live in fully socialized, cohesive family groups of adults, infants, and juveniles.

While zoos and research facilities are able to handle adult chimpanzees, however imperfectly, most individuals who purchase baby chimps cannot. Chimpanzees are relatively controllable only for the first few years of life. For this reason, many young chimps who start their lives as pets or entertainers are given to laboratories when they grow too big to handle. These chimps, who have been totally pampered while living with their owners, are unceremoniously dumped into labs where they are often isolated from either ape or human contact. In the entertainment business, some live into adulthood in horrific conditions—controlled by shock-collars or beaten by their trainers, living in small cages, forced to perform absurd acts, or even drugged to keep their natural energy at bay.

On the whole, though, all of the entertainment apes I photographed began their careers in a bygone era. I think the days are gone when people really think that Mr. Jiggs smoking and riding a motorcycle, or Cheetah—of *Tarzan* fame—turning his lip inside out and doing flips is funny. Times are changing. Audiences today often think that kind of animal act is neither amusing nor appropriate.

Despite this growing awareness of what constitutes humane treatment of chimpanzees, our notions of what makes chimps happy and what constitutes good care for them are still severely limited. It is not enough for us to provide only cinderblock cells as homes for animals who have given their freedom and health for human research needs. Nor is it fair to isolate animals with such highly developed social skills and needs. Chimpanzees, like humans, need rich environments, social stimulation, and physical freedom in order to thrive. With few exceptions, neither the testing, zoological, or entertainment industries have managed to consistently provide those things for them. While it is obvious that humans have learned a great deal about medicine from experiments on chimpanzees, it is also important that we continue to learn about the chimpanzees themselves and to use what we know to act responsibly towards them.

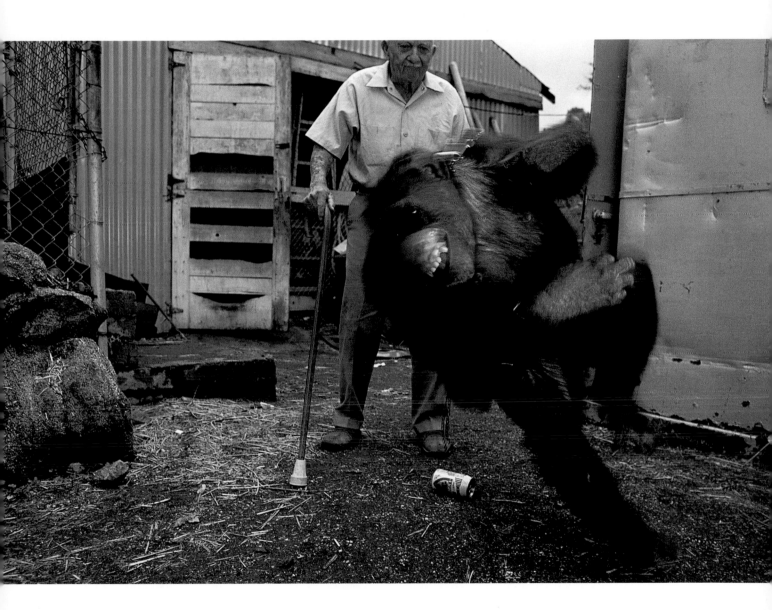

Above: Celebrity chimpanzee Cheetah starred with Johnny Weissmuller in the popular *Tarzan* movies. At fifty-six years old, Cheetah shared a daily beer and cigar with his trainer Tony Gentry. The two were retired together in Thousand Oaks, California, until Gentry's own failing health forced him to turn Cheetah over to another trainer.

Above: Busch Gardens Zoological Park in Tampa, Florida, is one of the most expensive chimp exhibits in the United States: several million dollars went into designing a chimp habitat to make it look more realistic. Such measures improve the look of the habitats for the zoo-goers only; they do little good for the animals. The chimps are often not properly socialized and feel the extreme pressure of captivity. In this exhibit, only female chimps and sub-adult males are allowed out in the viewing area; the aggressive adult male is kept out of public view. *Opposite*: A male chimpanzee throws dirt at the crowd at the North Carolina Zoological Park in Asheboro. Although many zoos have upgraded chimp enclosures to make them better resemble the animals' natural habitat, often, the most successful zoo habitats are the ones that provide mental stimulation by having giant jungle gyms installed to give the chimps a climbing and play area.

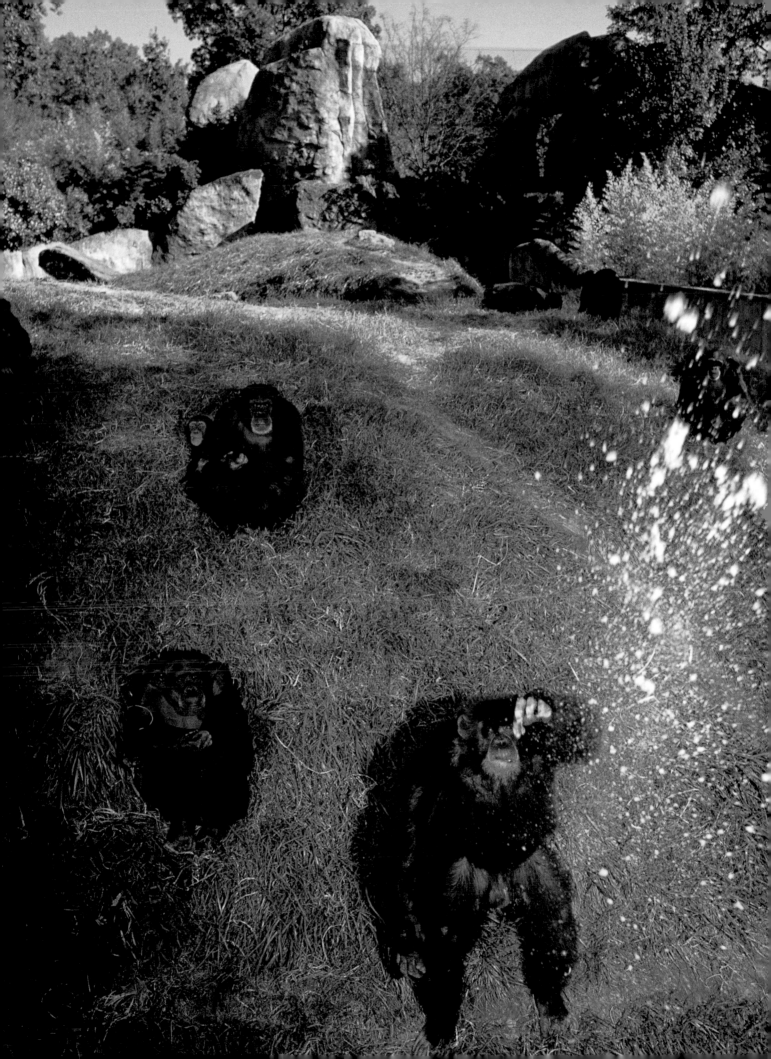

CHAPTER FOUR SANCTUARIES

ONCE REMOVED FROM THE WILD, WHETHER TO BE pets, entertainers, or research subjects, chimpanzees have never been successfully reintroduced into a habitat that has a wild-chimp population. Reintroduction attempts are still being made, but chimps in captivity lose their social skills and their abilities to cope in the wild, and the wild chimps simply destroy them.

Whereas some wildlife biologists feel that once chimps have been removed from the wild, they are a lost cause and all efforts and funding should be concentrated on the long-term issue of habitat protection, Jane Goodall's opinion is that the ethical and humane solution is to set up sanctuaries for these chimps, where they can live out their lives in safety and comfort. The cost of running these sanctuaries—domesticated chimps continue to require human care and feeding for the rest of their lives—is prohibitive and a huge sacrifice for all who undertake the task.

One sanctuary is the Chimfunshi Wildlife Orphanage, located on the 10,000-acre farm of David and Sheila Siddle in Zambia. The chimpanzees here all lost their mothers to poachers, and were traumatically captured and transported to be sold into the illegal pet trade. When the young chimps were discovered by the authorities, they were sent to the Siddles' sanctuary. At last count there were thirty-seven chimps. Two of the orphans came from as far away as Papua New Guinea.

In the United States, one of the largest sanctuaries is Primarily Primates, near San Antonio, Texas, which was founded in 1978 as an alternative to death for nonnative animals that are no longer wanted or needed in zoos, biomedical research, the pet trade, and the entertainment industry. Currently, Primarily Primates houses more than three hundred primates, including chimpanzees and orangutans. It is not open to the general public and depends entirely on donations to survive.

Primarily Primates rescued "Tyrone the Terrible" from the Toby Tyler Circus, where handlers would throw cups of water into his face and beat the side of his cage with rods to get him to make his magnificent chimp display. Also living at Primarily Primates is Joe, an old male chimp confiscated from The Snake Farm, a blue highway tourist attraction near New Orleans, where he had been billed as the world's largest and most ferocious "gorilla." I had seen Joe in 1986 when I was working on an essay on tourism; he was huddled in a corner of a dark cage filled with feces and cigarette butts. The owner had to feed and water him through a small opening in the bars, because the door to the cage was rusted shut. When Joe was freed, the door had to be cut open, and his muscles were so atrophied that he could not walk. When I saw Joe again four years later at Primarily Primates, he had regained the use of his limbs.

(conintued on page 120)

Opposite: **A group of young chimps calling out in greeting where David and Sheila Siddle have converted their farm into the Chimfunshi Wildlife Orphanage in Zambia. Big Jane perches above open-mouthed Boo Boo, dark-faced Little Jane, and Coco. David and Sheila struggle to knit stable groups with a recognized hierarchy, the natural pattern of the species.** *Page 114*: **In Pointe Noire, the Republic of Congo, a performer mimics an ape in swaggering gait and pant-grunts. Goodall responds with a chimp hoot. The dance celebrates the opening of the Tchimpounga Sanctuary for orphaned chimps, donated and constructed by Conoco, Inc. and run by the Jane Goodall Institute.**

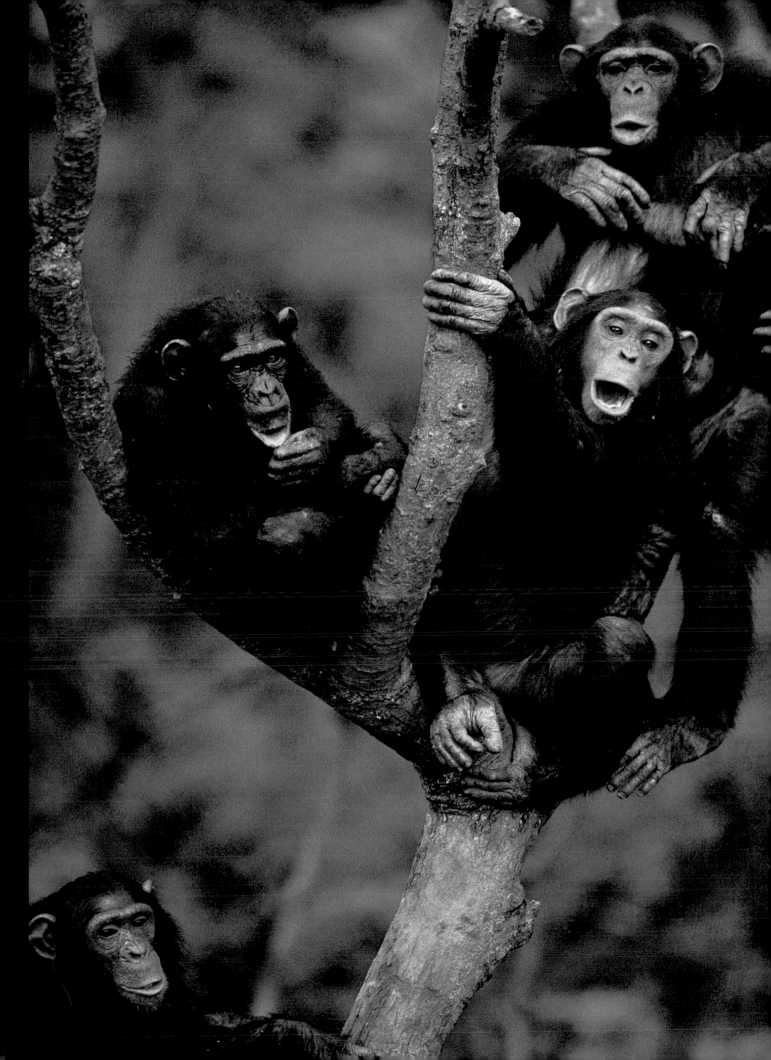

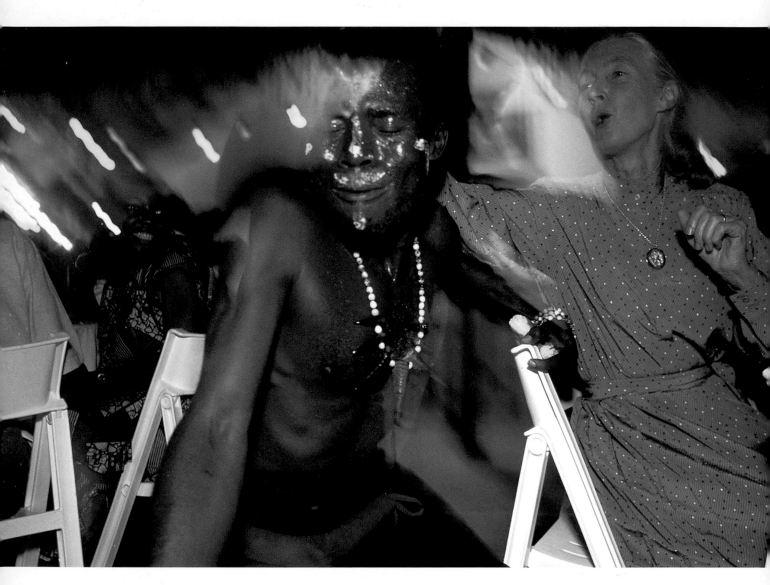

Opposite (top): Drink-time at the Tchimpounga Sanctuary. Older animals wait their turn as a keeper tends the youngest, still recovering from such nightmares as bullet wounds and the shock of seeing their mothers shot by poachers. Orphans arrive at Tchimpounga riddled with parasites and malnourished. They are given fortified milk and medicine as required. In a large electric-fence enclosure, these orphan chimps at Tchimpounga are completely dependent. Goodall struggles to support the sanctuary with constant fund-raising efforts. *Bottom*: The young son of a former zookeeper has been raised with Sophie, a former zoo chimp rejected by her mother. Sophie is now at the Sweetwaters Sanctuary in Kenya and is completely integrated into a chimp group. Chimpanzee youngsters, like human children, have an insatiable appetite for play, coaxing siblings and other community members into chase-games and tickling sessions.

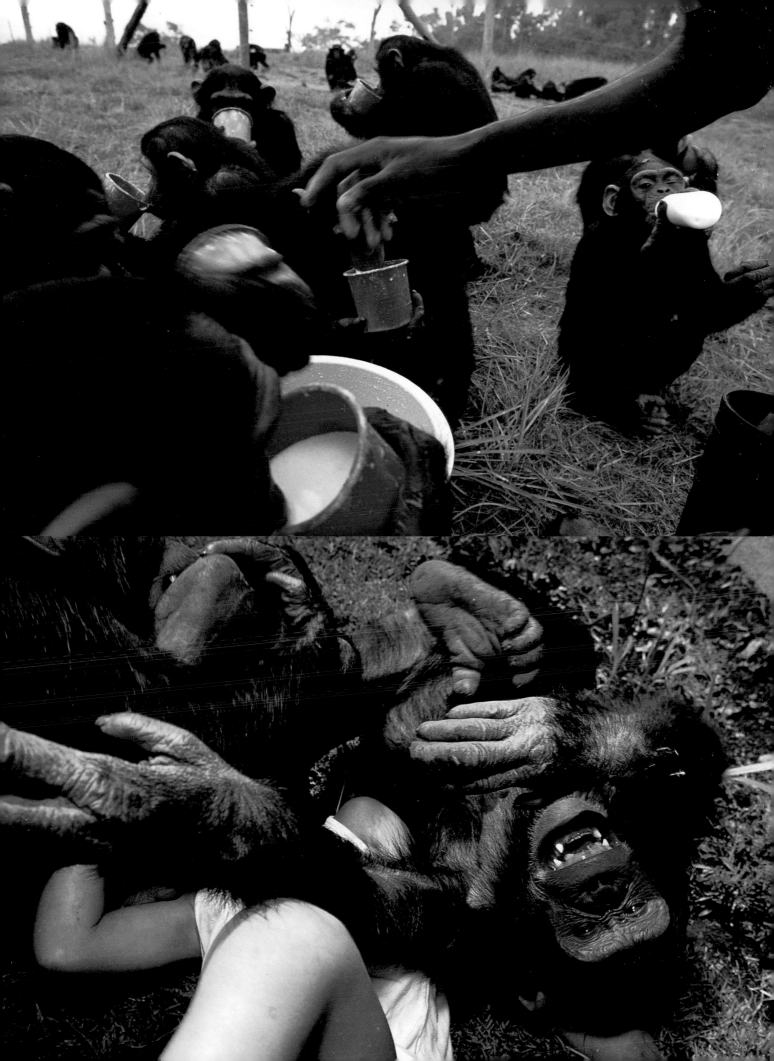

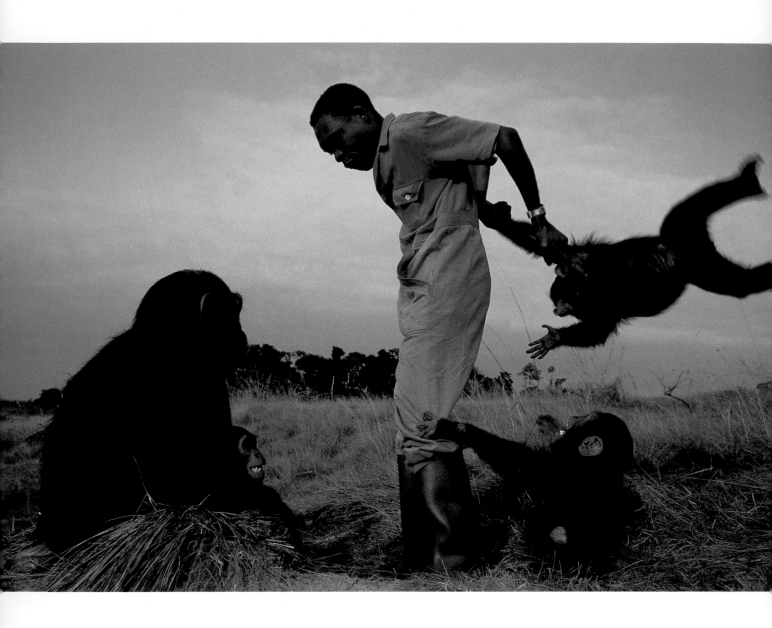

Pages 116-117: Maxillo, the alpha male of the Tchimpounga community, displays to establish his territory. *Above and opposite*: Playmates frolic around caretaker Ludovic Rabasa, who doubles as a surrogate parent to the fifty orphans at the Tchimpounga Sanctuary. The youngest chimps play in the forest each day with their keepers. This is the best possible semblance of balanced socialization with adult supervision.

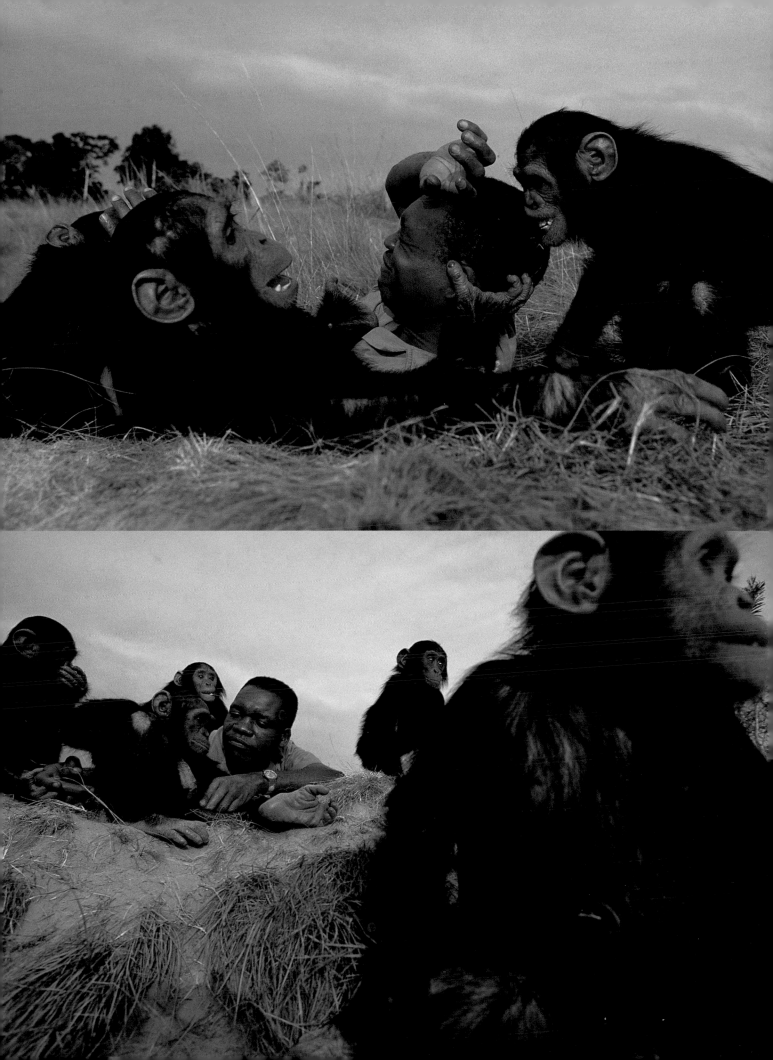

(conintued from page 112)

However, he still kept to himself and hoarded food like someone who had been a POW.

You can't ignore the chimps who are no longer wanted. But taking care of them in a sanctuary for fifty or sixty years is extremely costly, financially and emotionally. This is compounded by the fact that sanctuaries often allow their chimps to breed, which may be a mistake, as it only means more chimps who must be taken care of for their entire lives. But everyone wants the chimps to be able to have youngsters, because that helps to normalize and socialize them.

In some cases, chimps have been put on islands in the hope that they will regain their self-sufficiency. However, these experiments haven't worked well because the islands haven't generally had good native sources of food for the chimps, or even fresh water. Not surprisingly, these chimps still end up being very dependent on the humans who come on to the island to feed them.

There are areas of Africa that are chimp-habitable but have no chimp populations. If there weren't any people living too close by, you could try introducing sanctuary chimps into those areas. A chimpanzee to many Africans is just something wild that lives in the forest and can be eaten. Because they eat crops, destroying the hard work of farmers, and can be dangerous, it's not surprising that many people regard them as pests. But in Goodall's view, building sanctuaries in the same countries that have native chimp populations can help educate people about those animals still in the wild. If people go into the sanctuaries and see the chimps grooming one another and interacting, then they often suddenly can see that chimpanzees are very similar to humans.

The alternative to these sanctuaries is euthanasia or just to ignore the hundreds of orphan chimps from the bush-meat industry in Africa and from the pet, biomedical, and entertainment industries in our world.

I don't think that anyone can really look a chimpanzee in the eyes, and then kill it.

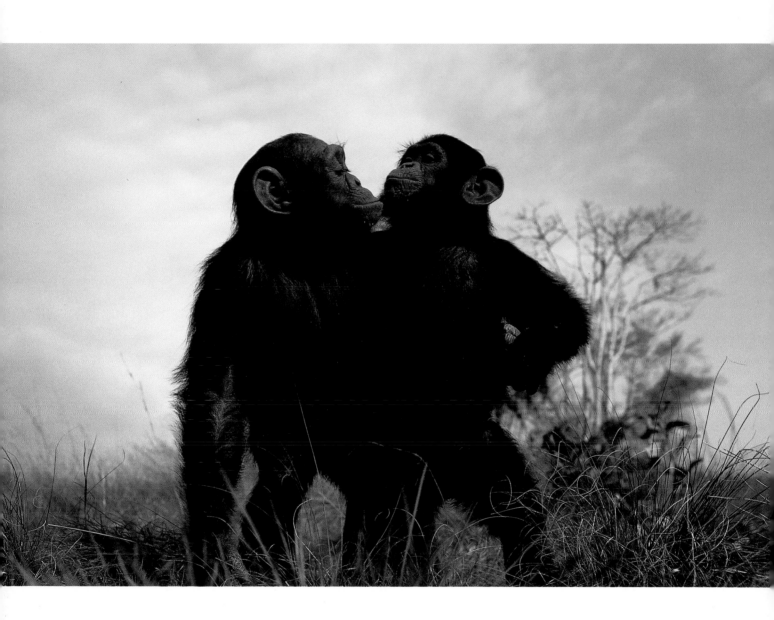

Fast friends, a pair of orphans face the future together at Tchimpounga. "Many conservationists feel it's a waste of money to build sanctuaries for orphaned chimpanzees," says Goodall. "Of course, saving habitat for the remaining wild chimps is desperately important. But not many people can look into the bewildered, traumatized eyes of an abandoned infant and turn away." Could you?

APERTURE GRATEFULLY ACKNOWLEDGES
THE GENEROUS SUPPORT OF

GERALDINE R. DODGE FOUNDATION

THE KENNETH A. SCOTT CHARITABLE TRUST,
A KEYBANK TRUST

THE TURNER FOUNDATION

FOR MORE INFORMATION
OR IF YOU WANT TO HELP

Jane Goodall, the leading authority on chimpanzee behavior, began her life-long crusade to reveal the existing bond between man and its closest relative, the chimpanzee, under the guidance of her mentor, the famed anthropologist and paleontologist, Dr. Louis Leakey. Soon after her work with Dr. Leakey, Goodall earned her Ph.D. in Ethology from Cambridge University and established the Gombe Stream Research Centre in Tanzania. Here, her groundbreaking scientific research—the longest continuous study of any wild animal—narrowed the gulf that previously was believed to exist between humans and chimpanzees. Her observations, such as the discovery of the making and use of tools by chimpanzees, forever altered the world's perception of the kinship between man and chimpanzee.

Goodall founded The Jane Goodall Institute for Wildlife Research, Education and Conservation (JGI) in 1977. The Institute's mission is to foster positive relationships between people, animals, and the environment, and protect and promote the well-being of chimpanzees in both the wild and captivity. Internationally recognized as the chimpanzees' greatest defender, Goodall has received numerous awards from the National Geographic Society, the Encyclopedia Britannica, as well as several honorary doctorates. Other honors include the Medal of Tanzania and the CBE from H.M. Queen Elizabeth II. Today Goodall continues her campaign for animal rights and, through her lectures, encourages people to rethink their relationship to the world and all of its inhabitants.

THE JANE GOODALL INSTITUTE SANCTUARIES

The Congo Republic

We completed our first full-scale sanctuary, near Pointe Noire in the Congo Republic, in December 1992. Twenty-five orphans came from a temporary holding facility at the Brazzaville Zoo, and nine were transferred from the Pointe Noire Zoo. The sanctuary is surrounded by electric fencing and includes spacious caging, a large savanna area, and an area of thick rainforest where the chimps spend most of their day. School children from Pointe Noire visit the sanctuary regularly. Because of the continuation of poaching and the government's cooperation in confiscating the orphan chimpanzees, we now have fifty-three chimpanzees living in the sanctuary.

Kenya

Chimpanzees are not indigenous to Kenya. The prime objective of the Sweetwaters Sanctuary in central Kenya, established in 1993 by Lonrho in close collaboration with the Jane Goodall Institute, is to provide shelter and care for orphan chimpanzees rescued from other areas. The sanctuary is located within the boundary of the 23,000-acre Sweetwaters Game Reserve, which was originally conceived as a black rhino breeding sanctuary. In 1994, due to the unstable political situation in the central African nation of Burundi, the Jane Goodall Institute requested permission from the Burundian and Kenyan governments to move the twenty chimpanzees from JGI's Halfway House in Bujumbura, to the Sweetwaters Sanctuary. The chimpanzees have settled well into their new home. The sanctuary also provides visual access for education and observational studies conducted by school children, primatologists, anthropologists, and others interested in chimpanzee behavior.

Uganda

We currently have two sanctuaries in Uganda. The original sanctuary is at the Entebbe Wildlife Education Center, formerly the Entebbe Zoo. In March 1995 we moved eight chimpanzees from the center to an island site in Queen Elizabeth Park. These eight now have more freedom to roam and more space to explore. And because chimpanzees don't swim, the natural barrier of water eliminates the need for fencing. Tourists can watch the chimpanzees from an offshore viewing platform, which they reach after a short boat ride. Plans are under way to improve the facilities of the sixteen chimpanzees who remain at the center.

Tanzania

The Kitwe sanctuary is on a beautiful peninsula jutting out into Lake Tanganyika just south of Kigoma, Tanzania, only two and a half hours by boat from Gombe National Park. The sanctuary was established in 1994 when Tanzanian authorities confiscated a group of young chimpanzees who had been smuggled from the Republic of Congo. Five young chimpanzees are now thriving under the care of the JGI-sponsored caretaker.

It is our hope that the government's crackdown on poaching, along with conservation education, will discourage habitat destruction and encourage the preservation of all forms of flora and fauna in each country. Although our long-term goal is for each sanctuary to become self-sufficient from tourist dollars, we now depend on the generous donations of Jane Goodall supporters and chimpanzee guardians to keep the sanctuaries operating.

For more information, please contact:

THE JANE GOODALL INSTITUTE
P.O. Box 14890
Silver Spring, MD 20911
1-800-592-JANE
www.janegoodall.org

THE JANE GOODALL INSTITUTE—UK
15 Clarendon Park
Lymington, Hants SO41 8AX
United Kingdom
+44 1590-671-188

THE JANE GOODALL INSTITUTE—CANADA
P.O. Box 477, Victoria Station
Westmount, Quebec H3Z 2Y6
Canada
1-888-882-4467

THE JANE GOODALL INSTITUTE—GERMANY
Herzogstrasse 60
Munich, D-80803
Germany
+49 89-34-22-99
+49 89-39-45-03

Other organizations doing excellent work on behalf of chimpanzees:

FAUNA FOUNDATION
P.O. Box 33, Chambly, Quebec J3L 4B1
Canada

CENTER FOR CAPTIVE CHIMPANZEE CARE
P.O. Box 3746, Boynton Beach, FL 33424
1-561-963-8050

CHIMFUNSHI WILDLIFE ORPHANAGE TRUST
P.O. Box 11190
Chingola, Zambia
+260-2-311293

INTERNATIONAL PRIMATE PROTECTION LEAGUE
P.O.Box 766, Summerville, SC 29484
1-803-871-2280
www.ippl.org

MONKEY WORLD
Longthorns, Wareham, Dorset BH20 2HH
England
+44 1929-462-537

It is obvious that I use photography as a tool of advocacy. As soon as I became aware of the plight of the chimpanzee at the hand of Homo sapiens I felt I had to make a strong statement and effect change by photographing and publicizing this obvious violation of rights.

The chimpanzee, and all apes for that matter, are revered, adored, even idolized by my culture because of their close relationship to humans. Their similarity to us in intelligence and genetic structure make it possible to learn from them about human thought, speech, sociality, and disease. Yet we refuse to extend to them even the most basic rights that beings with their intellectual and emotional qualities deserve, rights against cruelty and neglect, against confinement and isolation.

Brutal Kinship is about creating awareness and shame about our moral myopia. I say myopia rather than conscious wrongdoing or, simply, evil, because in no case did I find a human who was intentionally abusing any chimpanzee. The people in this book all willingly allowed me to photograph their chimpanzees, because they were unaware that anything was wrong, and I feel some guilt in presenting these pictures. The problem is one of blindness, of misguided love. I saw that the pet owners and, especially, the personnel at the medical labs truly care about the chimpanzees under their care. The caretakers at the biomedical facility are in the most awkward position. They do a job that has a tremendous emotional cost and have virtually no control over the physical conditions the chimps are under, because of the constraints of finance and experimental protocol. But this does not excuse them or us of our responsibility to make the sacrifices required to provide chimpanzees with better care and to make restitution to those whose lives we have so seriously damaged. If we can see that our treatment of chimpanzees has been and is wrong, then we will have truly evolved.

I hope the subjects of this book can see something fair in it and maybe even feel the pain of our vulnerable kin.

Michael "Nick" Nichols

ACKNOWLEDGEMENTS

This book is dedicated to Geza Teleki and Hugo Van Lawick III (Grub). Your help, in completely different ways, gave this work its beginnings.

Without the generous help of many individuals the photographs presented here could not have been taken. Those whose cooperation was most significant are mentioned below:

Shizoko Aizeda, Russel Amey and Steve Patch, Christophe Boesch and Hedgeweg Boesch- Achermann, Sally Boysen, Mimi Brian, Betsey Brotman, Thomas Butler, Kelly Coladarci, Rachel Cobb, Anthony Colllins, Graziella Cotman, Bob Dannen, Roseanne D'Ercole, William Domer, Anita Dondfrio, Catherine Dumergue and Pascal Vivier, Robert Edison, Ruth Eichorn, Donna Ferrato, and Phillip Jones Griffiths, J. Michael Fay, Neva Folk, Jo Folger, Vanne Goodall, William and Janet Harrop, Dennis Helmling, Aliette Jamart, Lisa Jones, Tom Kennedy, Frans Lanting, Dr. Martin Lazar, Rick Lee, Mary Lewis, Eugene Linden, Jenniffer Lindsey, James Mahoney, Mary Ellen Mark, Hali Matama, Steve Matthews, James Mayer, Rod MacAlister, Max Pitcher, and Dee Simpson of Conoco, Sylvie Menou, Neeld Messler, Kristian Mosher, Toshisada Nishida, Mae and Bob Noell, Alex Peale, Karen Pack, Dale Peterson, James Dan & Lucie Phillips, Ann Pierce, Alfred Prince, Les Schobert, Dr Margaret Sherman, David and Sheila Siddle, Brett Simison, Mary Smith, Sue and Duane Savage-Rumbaugh, Wally Swett, Mary Beth Sweetland, Susan Stenquest, Silvia Rebbot, Charlotte Uhlenbroek, Gini Valbuena, Dilys MacKinnon Vass, Bill Wallauer, Dan Westfall, Steve Winter, Ron Winters, and Richard Wrangham.

Chromatics in Nashville, Tennessee generously made the quality duplicate transparencies used in the production of this book.

As a personal note I would like to thank Melissa Harris, Nan Richardson, and Kate Glassner Brainerd for believing in this set of photographs and in different ways making this book happen.

Honor and thanks to Jane Goodall for giving her name, voice, and friendship to me and this work.

Lastly, I would like to thank my mate, Reba Peck, sons, Ian and Eli, and mom, Joyce Hall-Nichols. Nothing is possible without you and your love which travels with me always.

Library of Congress Catalog Card Number: 98-89097
Hardcover ISBN: 0-89381-806-2

Printed and bound by C&C Offset Printing Co., Ltd., Hong Kong

ART DIRECTOR: KATE GLASSNER BRAINERD

The Staff at Aperture for *Brutal Kinship* is:
Michael E. Hoffman, *Executive Director*
Melissa Harris, *Editor*
Stevan A. Baron, *Production Director*
Michelle M. Dunn, *Typography*
Lesley A. Martin, *Managing Editor*
Phyllis Thompson Reid, Nell Elizabeth Farrell, *Assistant Editors*
Helen Marra, *Production Manager*
Sara Federlein, *Development Manager*
Chelsea Knight, *Design Work-Scholar*
Tamara McCaw, Cara Maniaci, *Editorial Work-Scholars*

Aperture Foundation publishes a periodical, books, and portfolios of fine photography to communicate with serious photographers and creative people everywhere. A complete catalog is available upon request. Address: 20 East 23rd Street, New York, New York 10010. Phone: (212) 598-4205. Fax: (212) 598-4015. Toll-free: (800) 929-2323.
Visit the Aperture website at: http://www.aperture.org

Aperture Foundation books are distributed internationally through: CANADA: General/Irwin Publishing Co., Ltd., 325 Humber College Blvd., Etobicoke, Ontario M9W 7C3. Fax: (416) 213 1917. UNITED KINGDOM, SCANDINAVIA, AND CONTINENTAL EUROPE: Robert Hale, Ltd., Clerkenwell House, 45-47 Clerkenwell Green, London EC1R OHT. Fax: 44-171-490-4958. NETHERLANDS, BELGIUM, AND LUXEMBURG: Nilsson & Lamm, BV, Pampuslaan 212-214, P.O. Box 195, 1382 JS Weesp. Fax: 31-294-415054. AUSTRALIA: Tower Books Pty. Ltd. Unit 9/19 Rodborough Road, Frenchs Forest, New South Wales. Fax: 61 2 99755599. NEW ZEALAND: Tandem Press 2, Rugby Road, Birkenhead Auckland 10, New Zealand Fax: 64-9-480-14-55. INDIA: TBI Publishers, 46, Housing Project, South Extension Part-I, New Delhi 110049, India. Fax: (91) 11-461-0576.

For international magazine subscription orders for the periodical *Aperture*, contact Aperture International Subscription Service, P.O. Box 14, Harold Hill, Romford RM3 8EQ, England. Fax: 1-708-372-046. One year: £30.00. Price subject to change.
To subscribe to the periodical *Aperture* in the U.S. write Aperture, P.O. Box 3000, Denville, New Jersey 07834. Toll free: (800) 783-4903. One year: $40.00; two years: $66.00.

First edition
10 9 8 7 6 5 4 3 2 1